IMAGES
of Modern America

ADVENTURELAND

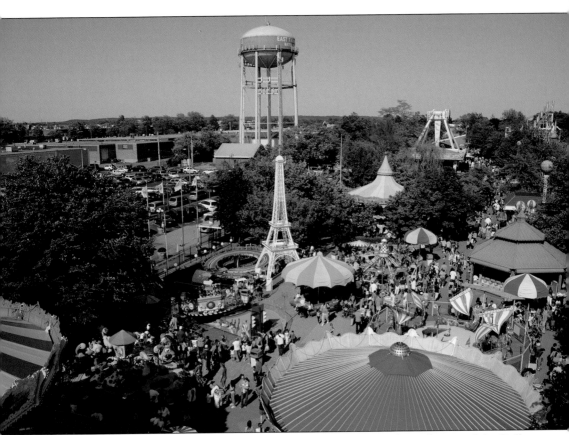

MEMORIAL DAY 2013 AERIAL VIEW. A very full park is seen here from the top of the Balloon Wheel Ferris wheel. The Flying Puppies (introduced 2009) and the Tour de Paris Kiddie Car Ride (introduced 2003) visible in this picture were both retired at the end of the 2013 season to make way for two new 2014 additions, the Tea Cups and NYC Race attractions. (Courtesy of the author's collection.)

IMAGES
of Modern America

ADVENTURELAND

Christopher Mercaldo

ARCADIA
PUBLISHING

Published by Arcadia Publishing
Charleston, South Carolina

Printed in the United States of America

Library of Congress Control Number: 2013952316

For all general information, please contact Arcadia Publishing:
Telephone 843-853-2070
Fax 843-853-0044
E-mail sales@arcadiapublishing.com
For customer service and orders:
Toll-Free 1-888-313-2665

Visit us on the Internet at www.arcadiapublishing.com

For Tony, Paul, and Steve

CONTENTS

ACKNOWLEDGMENTS

This book would have been impossible without the help and support of the entire Adventureland family, team, and community. The Adventureland staff, both past and present, was extraordinarily helpful and insightful throughout the entire book-writing process.

Special thanks go to the Gentile family, Chip and Kathy Cleary, Chris Collins ("Surf Dance Chris"), and, of course, my own incredible parents, siblings, and family for their endless love and support.

Unless otherwise noted, all images appear courtesy of Adventureland Long Island's collection of photographs.

INTRODUCTION

Adventureland Long Island has been entertaining guests for over 50 years. The family-owned-and-operated amusement park opened in 1962 as Adventures 110 Playland before becoming 110 Adventureland and then Adventureland.

In its over-50-year history, the park has seen countless changes. These include several changes in ownership, many changes in rides, and even changes in guest preferences.

Adventureland has become both a time machine and a small world all its own. It provides an escape for Long Island families to get away for the day and enjoy making fun family memories together. At the same time, the park instantly transports both the young and the young at heart back to a first ride on a favorite attraction, even if it has long since been retired.

This book documents the many changes that this small, locals' amusement park on Long Island has seen during its lifetime, decade by decade. With many parents and even grandparents today having visited Adventureland themselves when they were children, this book is sure to provide instant memories of the past and hopes to inspire more Adventureland memories for the future.

Enjoy!

One

1960s

Something for Anyone

Lying on a beach in Miami in the winter of 1956, Alvin H. Cohen and good friend Herbert Budin discussed their current unhappiness with their lines of work. "Why not an amusement park?" asked Cohen. "Why not?" replied Budin. With the dream now born, these two young men would travel the United States for the next four years studying, researching, and learning everything that they could about the amusement park industry.

In 1960, they purchased a six-acre chicken farm on Route 110 to be the site of their park because of its easy access to main roads. It was a smart decision, as the Long Island Expressway would be extended to Route 110 only a few months later, jump-starting the population boom of Long Island's Suffolk County.

According to a September 17, 1972, article in *Newsday*, Cohen wanted "something for anyone of any age where you can eat, relax, and have fun." Adventureland, which he opened in 1962, would be just that.

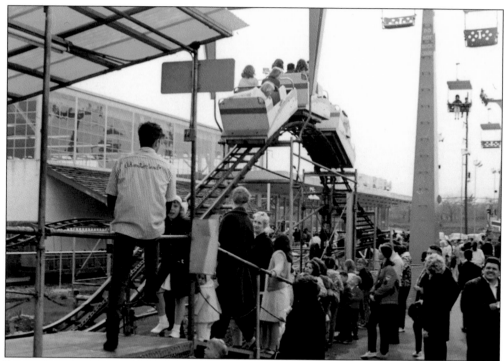

LITTLE DIPPER ROLLER COASTER, C. 1964. Adventureland's first roller coaster was an Allan Herschell Little Dipper model. Approximately 117 similar coasters were produced by Allan Herschell and were purchased by parks both large and small throughout the country.

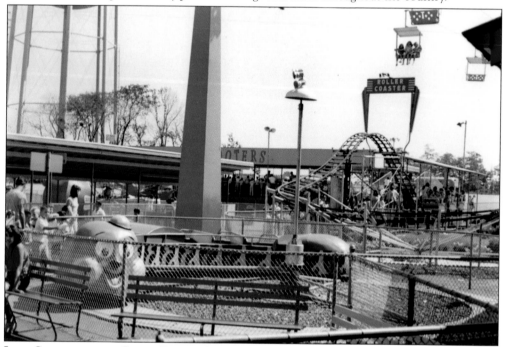

JOLLY CATERPILLAR AND LITTLE DIPPER, AUGUST 1965. Adventureland's first Crazy Caterpillar–style attraction was the Jolly Caterpillar. A much-updated version was added to the park in 2001.

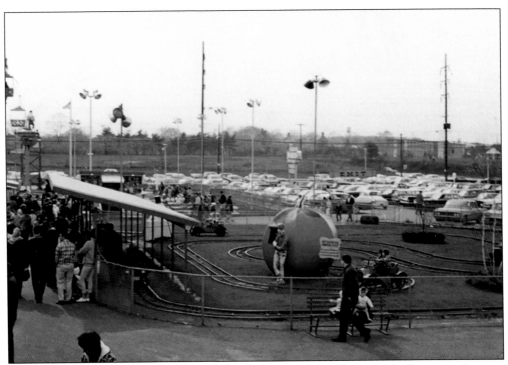

FRONT OF PARK, C. 1965. This overview of the front of the park overlooks the entire Antique Autos attraction and the park's original parking lot as well. Also visible is the oversized pumpkin that can still be seen at the park today from the 110 Express train.

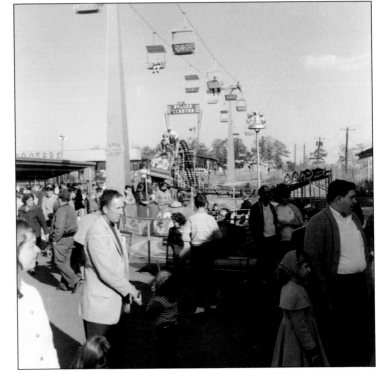

A LOOK DOWN THE MIDWAY, OCTOBER 1965. Visible in this picture are the Skooters building (a bumper car ring), Skyliner attraction, the Little Dipper roller coaster, and the Jolly Catepillar. It is interesting to note the Sunday best worn by the park's guests during this era.

HAND CAR RIDE, OCTOBER 1965.
Always a popular children's attraction, the handcars featured here were likely produced by the Hodges' Amusement & Manufacturing Company. Children would crank the two knobs forward with their hands to move their vehicles forward.

MINIATURE GOLF AND SKYLINER, OCTOBER 1965.
Featured here is the park's original miniature golf course. To the right of the picture is the indoor structure that allowed Adventureland to be a year-round operation by housing several attractions and arcade games inside as well. Right overhead is the park's Skyliner skyway attraction.

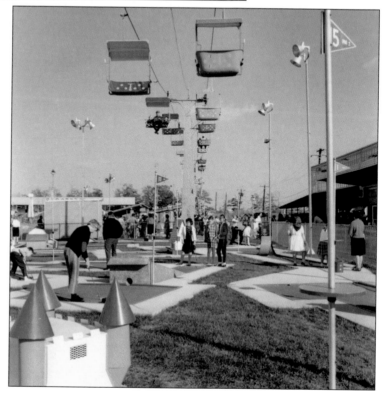

ANTIQUE AUTOS, HELICOPTERS, AND SKOOTERS, OCTOBER 1965. The park's original Antique Autos was the first of three incarnations of antique-car rides. Behind it is the park's first Helicopters attraction, manufactured by Chance, which would exist at the park through the 1994 season.

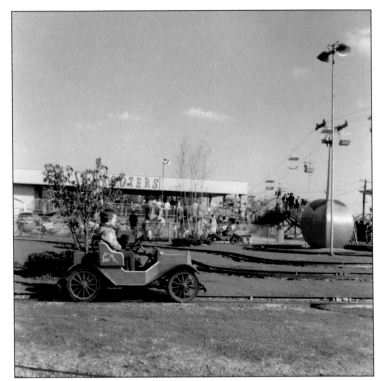

ADVENTURELAND TRAIN, JULY 1965. The Adventureland Train has circled the park since 1962. While it has undergone several name changes, and the boarding point for guests has changed several times as well, the Adventureland Train continues to be a popular attraction that all guests can enjoy for a grand circle tour of the park.

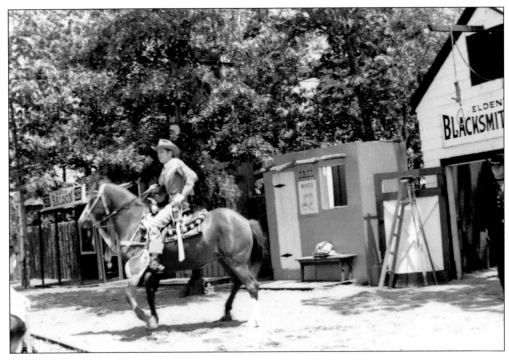

DAVEY DIXON AND WONDER HORSE HONEY GIRL, C. 1965. Adventureland welcomed Davey Dixon and his Wonder Horse Honey Girl for a series of performances at the park. Westerns were the most popular genre of television series and films in the 1950s and 1960s, and Davey Dixon and Honey Girl traveled the country performing cowboy- and Western-inspired stunt shows for guests.

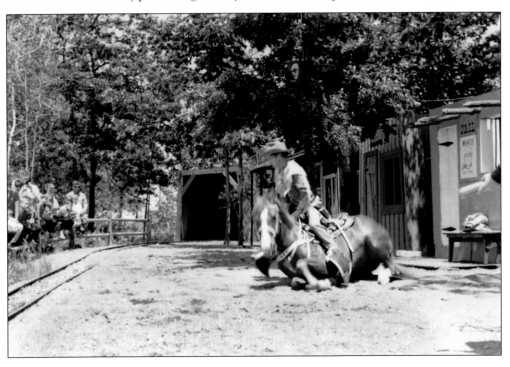

ENTRANCE TO FRONTIER TRAIN, AUGUST 1965. Here, the original name of the Adventureland Train—the Frontier Train—is present on signage. A ride on the train in 1965 cost only 25¢. This is the indoor structure that today houses the arcade.

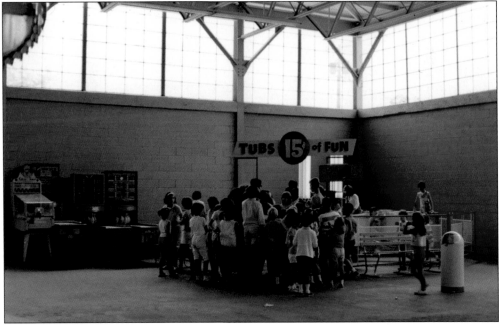

TUBS OF FUN, JULY 1965. Adventureland's first iteration of the Tubs of Fun can be seen here in the indoor structure that housed several arcade-style games and rides. As in the similar teacups-style rides found in other parks around the world, guests freely turn a wheel in the center of their tub to control the speed of their spin. To the left of the ride are a few very classic puck-slide bowling arcade games.

SPEED BOATS, JULY 1965. These kiddie speedboats would be the oldest surviving opening-day attraction at Adventureland when they were removed at the end of the 2002 season after 40 years of service. Many little thematic touches would be added to the attraction once it was moved permanently outdoors later in its life, and countless children enjoyed captaining their own boats during the ride's lifetime.

Two

1970s
Rapid Expansion

Alvin H. Cohen would double the park's size from six acres to twelve acres and continue to add new attractions each year. According to Jim Futrell's *Amusement Parks of New York*, Cohen had leased the park's Troika and Enterprise attractions from Willy Miller, "a German immigrant who came to the United States in 1972 and started a ride-importing business." Miller took great interest in Adventureland, and Cohen would sell the park to him at the end of the 1977 season.

During Miller's ownership, from 1977 to 1987, the park would see many new attractions added, making for an unprecedented internal expansion.

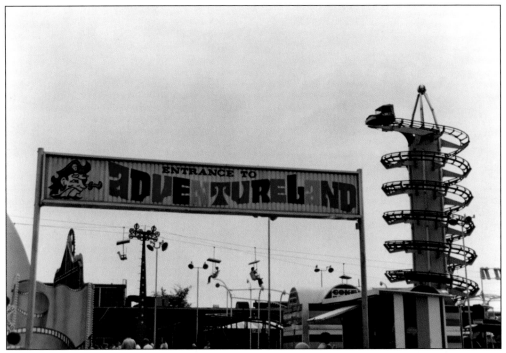

ENTRANCE TO ADVENTURELAND, OCTOBER 1978. Visible here is the entrance to the park in October 1978. Shown are the park's popular 1970s word-type logo, the pirate-with-the-sword-in-his-mouth logo that was used at the park from the 1960s through the early 1980s, the Toboggan roller coaster, the Skyliner, and the entrance to the park's Omnivision Cinema 180 theater.

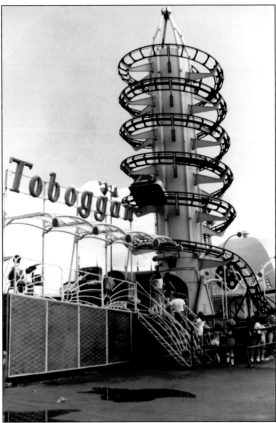

TOBOGGAN ROLLER COASTER AND CINEMA 180, C. 1978. The Toboggan roller coaster greeted guests near the front of the park and was a fan favorite for many years between 1973 and 1979. Guests boarded caged, single-bench cars before beginning a vertical ascent up a lift hill located inside of the center tower and spiraling down and around the 45-foot-tall tower itself. After its last season in 1979, the Toboggan was sold to a traveling fair in Brazil.

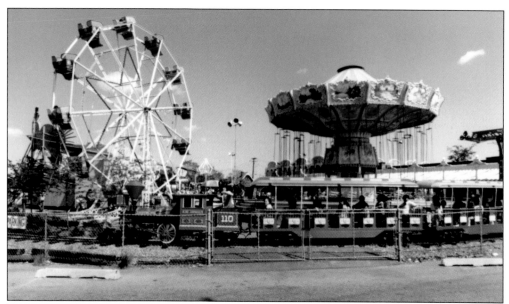

FRONT OF PARK, C. 1979. This is a view from the front of Adventureland from the retired front parking-lot area (before this area was filled in with gravel and grass and a more permanent wrought iron fence replaced the chain-link fence present here). Visible in the picture are the Adventureland Train, Ferris Wheel, Wave Swinger, Flower Jet, and Skyliner attractions.

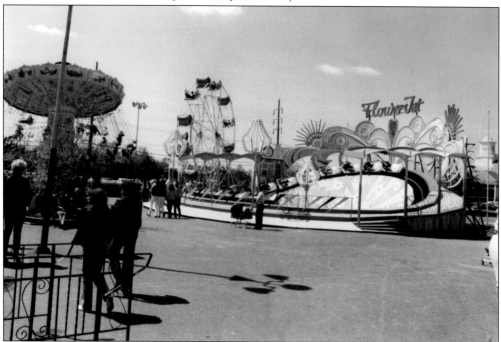

WAVE SWINGS, FERRIS WHEEL, AND FLOWER JET, C. 1979. The Zierer-manufactured Wave Swinger on the left, one of the first of its kind brought in from Germany in 1974, has proven to be an Adventureland staple. This original model would provide over 30 years of service to the park. Also visible are the Eli Bridge Company–manufactured Ferris Wheel and the Schwarzkopf-manufactured Flower Jet.

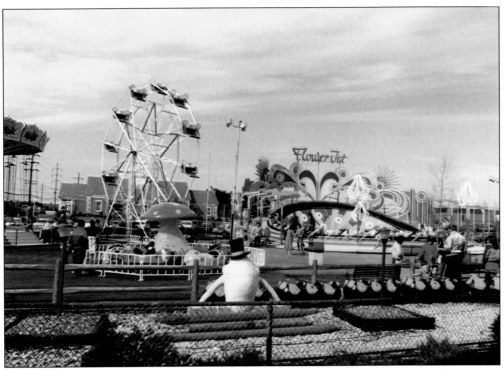

FLOWER JET, WORM, AND GRANNY BUGS, C. 1979. The Flower Jet, a version of the popular Schwarzkopf Bayern Curve, had an absolute top speed of approximately 75 miles per hour but was often run at a maximum speed of about 40 miles per hour. The park's Worm ride is the renamed Jolly Caterpillar ride from the 1960s, and another classic-style attraction, the Granny Bugs, is seen in this image as well.

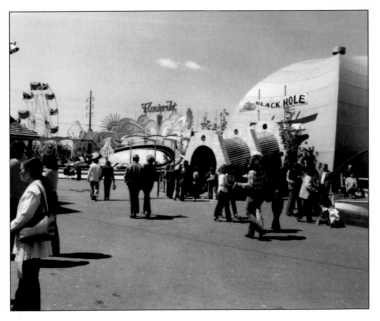

FLOWER JET AND THE BLACK HOLE, C. 1980. The Omnivision Cinema 180 theater (that later became the Black Hole) would entertain guests through the 1979 season with its unique 70-millimeter footage projected onto a 180-degree dome screen via special fisheye lenses. Similar Cinema 180 theaters, often manufactured by Hollingsworth, could be found at other amusement and theme parks around the world.

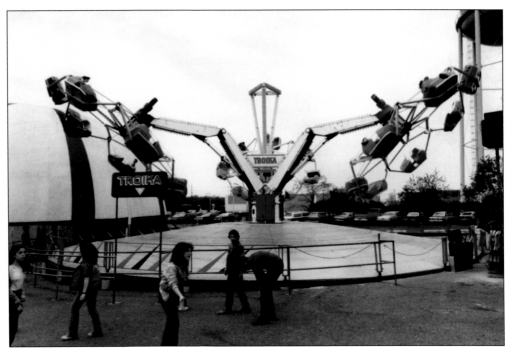

TROIKA, C. 1976. The Troika, a HUSS Park Attractions–manufactured ride, was a popular park-model attraction in the 1970s. HUSS would go on to manufacture many of Adventureland's favorite attractions over the years, including the Pirate Ship and the Frisbee. The Troika's three arms would raise, the center column would rotate clockwise, and the stars holding the gondolas would spin counterclockwise, providing a moderate thrill for guests.

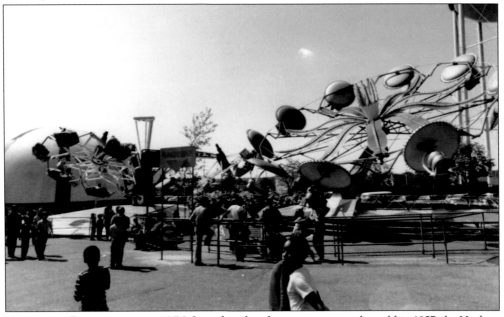

TROIKA AND PARATROOPER, C. 1976. Introduced to the amusement park world in 1957, the Hrubetz & Company Paratrooper was available in both park and portable versions that could be found at countless amusement parks, both large and small, across the country.

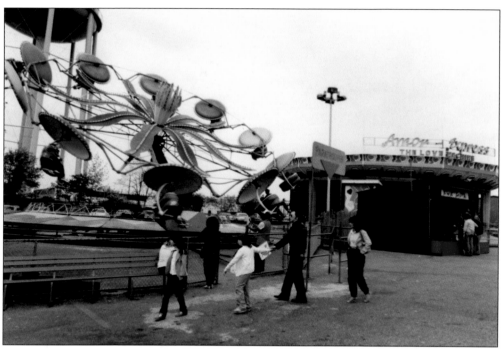

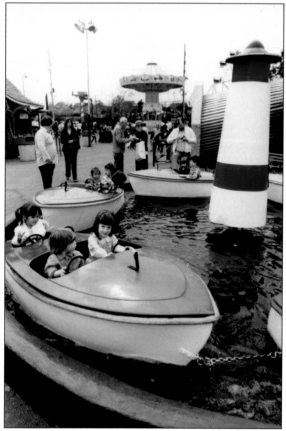

PARATROOPER, POP 'EM GAME, AND AMOR EXPRESS, C. 1978. The Paratrooper featured 10 gondolas that could carry two passengers each for a total of 20 riders. The gondolas would swivel as they went around in a circle, providing guests with a mild thrill. The Pop 'Em Game was a balloon-and-dart game, and the Amor Express was the predecessor to the park favorite Music Express attractions.

SPEED BOATS, SKYLINER, AND WAVE SWINGER, C. 1978. Present here are the Speed Boats, Skyliner, and Wave Swinger. The Speed Boats are the same as the ones that could be found indoors during the 1960s. Now outdoors, a lighthouse had been added to the center hub.

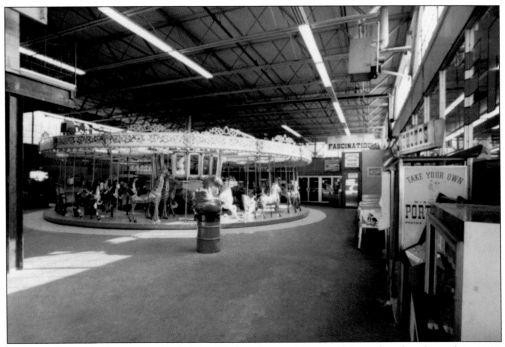

WILLIAM DENTZEL CAROUSEL, 1978. This William Dentzel Carousel, introduced to the park in 1962, was handcrafted. Each horse, animal, and chariot was carved from wood and then hand painted by the Dentzel Carousel Company. This particular carousel would leave the park shortly after 1978.

ENTERPRISE AND SPEED BOATS, C. 1978. This HUSS Park Attractions–manufactured Enterprise was introduced to the park in 1976. The ride featured 20 gondolas that could freely swing as the circular frame spun them clockwise and the central arm raised the circular frame holding them to a near-vertical position. It was the first nearly upside-down attraction for many guests.

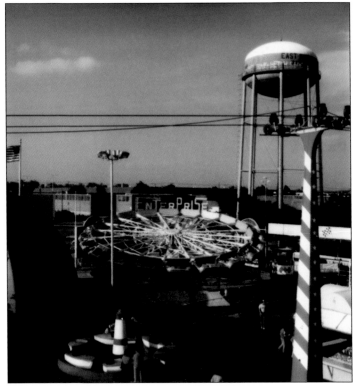

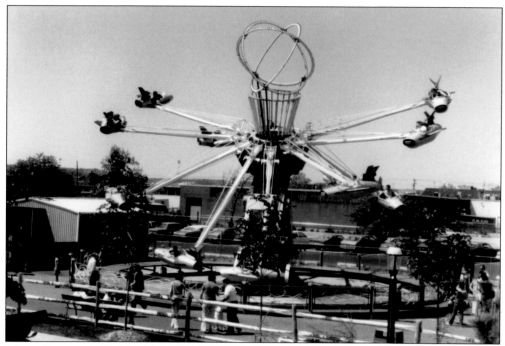

MOON TAXI, C. 1978. The Moon Taxi allowed guests to pull back or push forward on a lever that would cause their rocket ship to rise up or fly lower to the ground. The Moon Taxi was a Satellite Jet–model ride manufactured by the firm of Kasper Klaus.

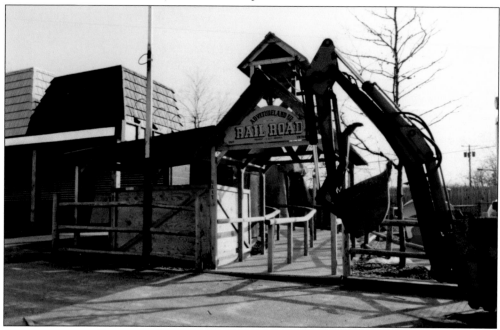

ADVENTURELAND RAILROAD STATION CONSTRUCTION, C. 1978. The Adventureland Railroad would undergo many name and station changes during its lifetime. It would move again from this second location to outside of the restaurant, where it would remain for about 20 years until the park's 50th anniversary in 2012.

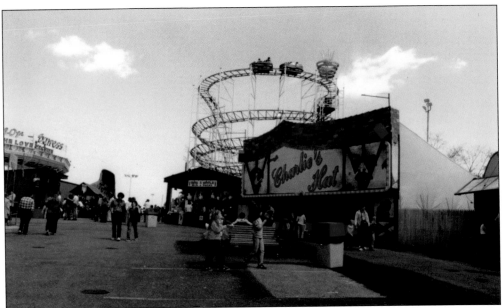

A LOOK DOWN THE MIDWAY, C. **1980.** On the left are the Amor Express, manufactured by Italian company Spaggiari, Duce & Casoli, and the new-for-1980 dark ride titled the Lost Continent. On the right is a midway game titled Charlie's Hat, with another midway game, Ring A Bottle, behind it. Looming over both midway games is the park's first big roller coaster, the Galaxi.

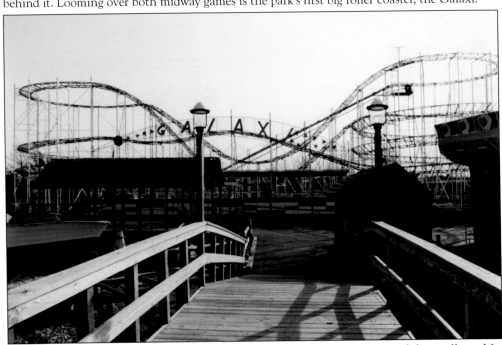

THE GALAXI ROLLER COASTER, C. **1979.** This view from the bridge that crossed the small pond for the park's radio-controlled boats shows the Galaxi roller coaster. Manufactured by SDC (Spaggiari, Duce & Casoli of Italy), its circuit is almost completely visible in this view. The Galaxi featured 1,099 feet of track and reached speeds of up to 31 miles per hour during its over-two-minute duration from start to finish.

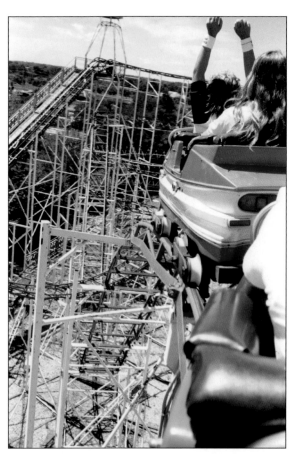

HANDS UP ON THE GALAXI, C. 1978. This Galaxi roller coaster train is about to descend the roller coaster's second drop. The Galaxi at Adventureland is featured in the 1986 film *Sweet Liberty*, which stars Michael Caine and Alan Alda and was also written and directed by Alda.

TILT-A-WHIRL, OCTOBER 1978. The Adventureland Tilt-A-Whirl was a Sellner-manufactured ride that provided guests with a classic and unforgettable experience. The Tilt-A-Whirl has been an amusement park and carnival staple for almost 90 years, having been first introduced to the industry in 1926.

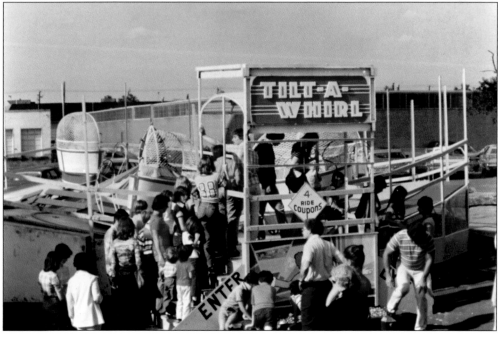

ANTIQUE CARS, C. 1978. Gas-powered cars driven on a steering-guide rail were all the rage in the 1970s. With the big success of the various Autopias at Disneyland and the Tomorrowland Speedway at the Magic Kingdom, parks both old and new throughout the country introduced similar attractions. The one pictured here was the second iteration of an antique-cars ride to exist at the park.

JAMAICA STATION ADVERTISEMENT, AUGUST 1979. This advertisement could be seen at the Long Island Railroad's Jamaica Station, one of the major hubs of the Long Island Railroad system. Featured at the top of the poster is the word-type logo that Adventureland would use heading into the 1980s. (Courtesy of Chip and Kathy Cleary.)

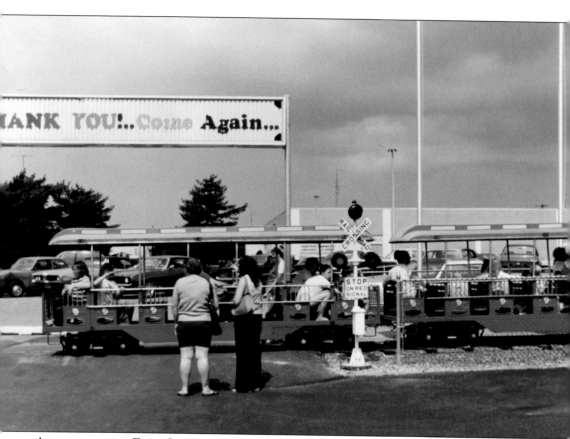

ADVENTURELAND EXIT, OCTOBER 1978. The tail end of the train passes by with the Allan Herschell railroad-crossing sign ringing and blinking away. This is the side exit of the park that leads to the main ticket booth today. Overhead, a large banner thanks exiting guests for coming to Adventureland and kindly asks them to return soon. Countless generations of Long Island guests would do just that.

Three

1980s
EXCITING EIGHTIES

In 1978, Willy Miller brought his German countryman and ride expert Udo Storck and the sharp young eye of Long Islander James "Chip" Cleary onboard his team. Together, they would go on to make spectacular changes at the park, including the addition of new themed areas and countless new attractions.

Udo's knowledge of and eye for amazing, blockbuster attractions could be seen through the introduction of great and thrilling German and other European-manufactured rides. Udo was also a back of house mechanical master.

Chip's eye for rides, theatrics, and beautification of the park could be seen through the addition of the iconic 1313 Cemetery Way dark ride, the Bavarian Village, and Pirate's Plaza. Chip was also a front of house management master.

Adventureland would change ownership again in 1987 when Miller would sell his interest to Tony Gentile's partnership team. Like previous ownership, Gentile's partnership team would quickly start expanding and adding to the park as well.

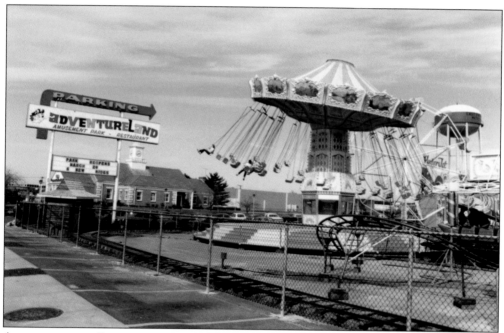

ADVENTURELAND ENTRANCE, C. 1983. This is the entrance to Adventureland at the beginning of the 1983 season. The marquee on Route 110 advertises six new attractions for the 1983 season; some of these include the UFO, Cap'n Wild Willy's Bumper Boats, and the Looping Star that had been introduced at the end of the 1982 season.

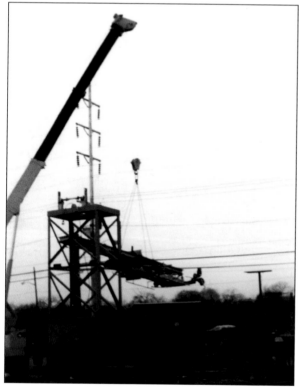

SKYLINER DECONSTRUCTION, C. 1981. The park's Skyliner skyway-style attraction was removed in the early 1980s. The footers for the Skyliner beams were embedded so deeply into the ground, however, that plants and trees today still do not take in the areas where they once stood.

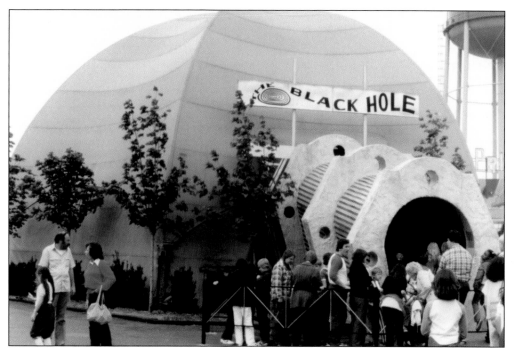

THE BLACK HOLE, 1980. The Black Hole was a complete reimagining of the park's retired Cinema 180 theater. Prior to the 1980 season, the tent-like structure was gutted of its theater system and a Chance Trabant (predecessor to today's Chance Wipeout rides) was installed inside. A special lighting package and sound system were also installed to add a thrilling and disorienting effect to the attraction. (Courtesy of Chip and Kathy Cleary.)

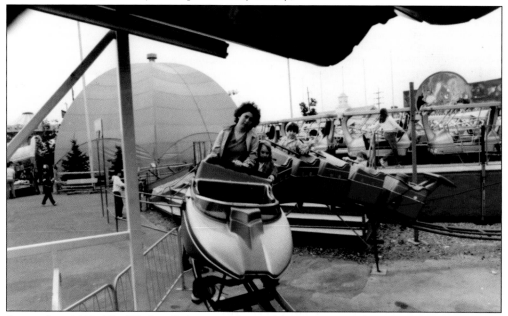

SOOPER JET, 1982. The Wisdom Rides–manufactured Sooper Jet, seen here in its inaugural season, is sporting a pink paint job on its powered coaster train. The rear car has an electric motor that powers the train as it makes its way around the circuit of roller coaster track.

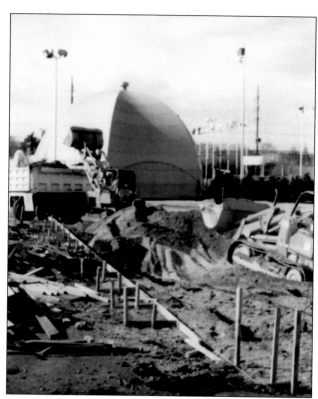

Cap'n Wild Willy's Bumper Boats Excavation, Winter 1982. One of Adventureland's most beloved and missed attractions, Cap'n Wild Willy's Bumper Boats, is seen here under construction. In this image, excavation is underway here for what would be a 100,000-gallon pool.

Bumper Boat Excavation and HUSS Troika Removal, Winter 1982. Visible in this picture are the continued excavation of the 100,000-gallon pool for Cap'n Wild Willy's Bumper Boats and, in the background, the removal of the park's HUSS Troika.

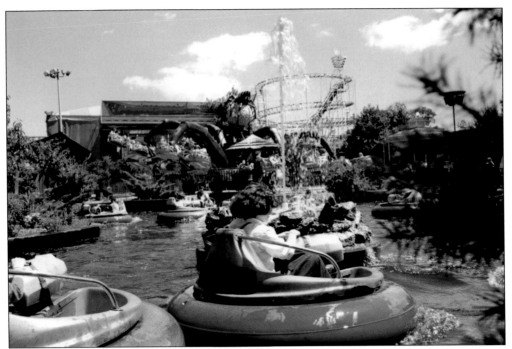

CAP'N WILD WILLY'S BUMPER BOATS, SCORPION, AND MUSIC EXPRESS, 1987. Pictured here is Adventureland's first set of bumper boats—Water Bugs—manufactured by J&J Amusements. The water in the first few seasons appears to have been dyed a slightly bluish tint. Behind the Bumper Boats is the park's Schwarzkopf Polyp ride, the Scorpion. Behind the Scorpion is the park's Music Express attraction that replaced the Amor Express.

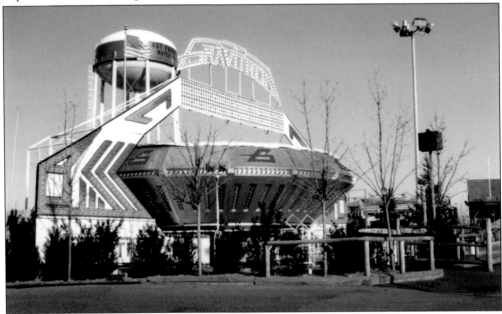

GRAVITRON, 1984. This Wisdom Rides Gravitron was a park favorite for several years. The Gravitron replaced the Black Hole and provided a similar thrilling-in-the-dark experience with spinning, lighting, and music. Wisdom Gravitrons and Starships continue to be popular fan favorites today.

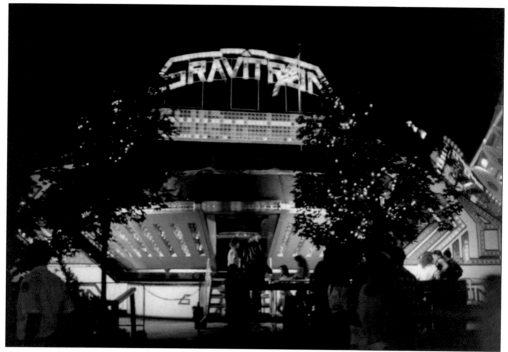

GRAVITRON AT NIGHT, 1984. The lighting package on the Gravitron made it stand out and glow at night, creating the appearance of a spaceship or a flying saucer. Once inside, guests would position themselves flat against the walls on individual roller panels. As the gondola began to spin, the individual roller panels would glide upwards, holding the guests in midair until the ride slowed down.

LOOPING STAR ARRIVAL, 1982. One of Adventureland's most beloved and missed attractions is the Looping Star. A portable Ranger model manufactured by HUSS Park Attractions, it is seen here arriving at the park. The Mack truck seen in the picture has been responsible for carrying and pulling numerous Adventureland attractions across the country and even to different spots within the park.

LOOPING STAR AND SPACE AGE, 1982. The Looping Star is featured on one of its first days of operation at the end of the 1982 season. To the right is the park's Hampton-manufactured Space Age kiddie ride. The Looping Star's distinctive motor-whirring noise could be heard up and down the Adventureland midway while the ride was in motion.

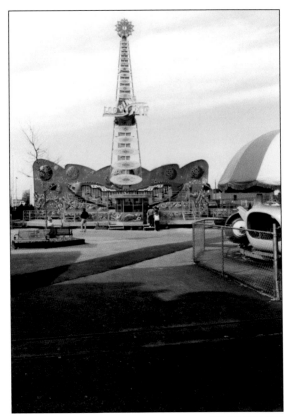

MIDWAY FROM ABOVE, 1987. In this view looking down the Adventureland midway, one can see on the left the Sooper Jet, Granny Bugs, Space Age, Helicopters, Gravitron, Looping Star, Cap'n Wild Willy's Bumper Boats, Scorpion, and Music Express. On the right are the old Whac-A-Mole game and structure, the old Main Ticket Booth, the Frog Bog game and structure, Kiddie Swings, Tubs, recording studio, games, Gazebo, and Galaxi roller coaster. (Courtesy of Chip and Kathy Cleary.)

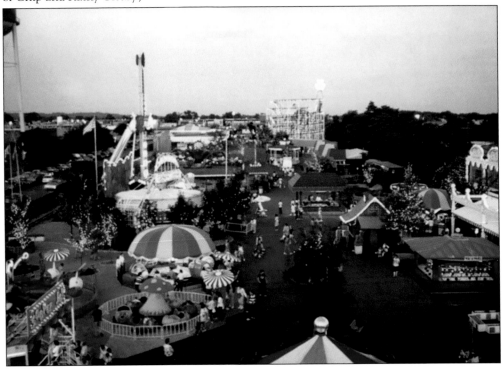

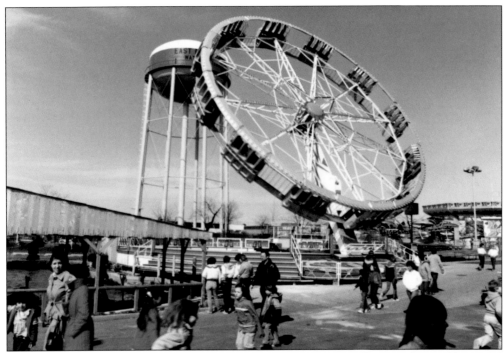

UFO, 1983. A traditional Round Up meets Enterprise, the UFO was also manufactured by HUSS Park Attractions. Guests would board the attraction and stand inside one of a dozen gondolas that held four riders each. The central hub would then rotate the 12 gondolas while the hydraulic arm in the center lifted upward. Centrifugal force would hold guests in place as they stood up against the back walls of their gondolas. Seen in the background are the Bumper Boats, Paratroopers, and Amor Express. (Courtesy of Chip and Kathy Cleary.)

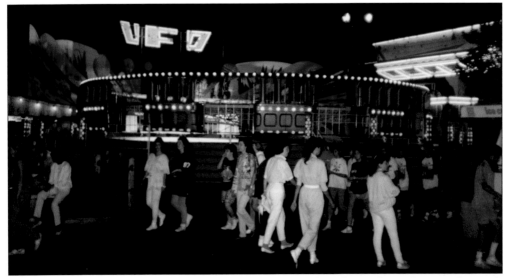

UFO AT NIGHT, 1985. At night, the UFO and the rest of the rides in the park came alive with their unique lighting packages. The UFO is pictured here at its loading position, horizontal with the ground. Like the Enterprise, the attraction would rise to a near-vertical position mid-cycle. (Courtesy of Chip and Kathy Cleary.)

1001 NACHT, 1984. The Weber-manufactured 1001 Nacht, in the location of the former Amor Express and future Music Express, would have its main arm travel in a motion similar to that of the Looping Star. The gondola, however, would rotate in a manner to stay horizontal with the ground. The attraction's name translates into English as *1001 Nights*, a reference to the collection of West and South Asian stories and folktales that make up the theme of the ride.

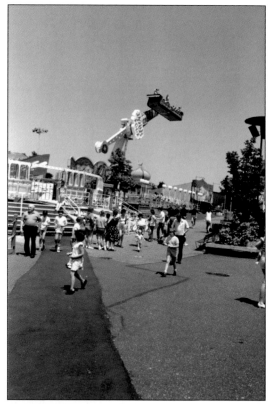

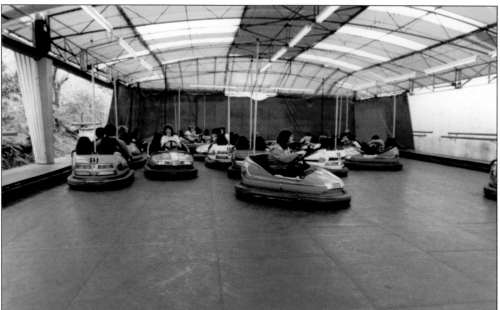

BUMPER CARS AND BUMPER CAR RING, 1983. Before a more permanent bumper car ring was erected, this portable bumper car ring existed in a location similar to its current one. Bumper cars had been a staple of the park since its early years. These are getting their electric power via a stinger, a pole in the back of the vehicle that connects it to the electrically conductive ceiling above.

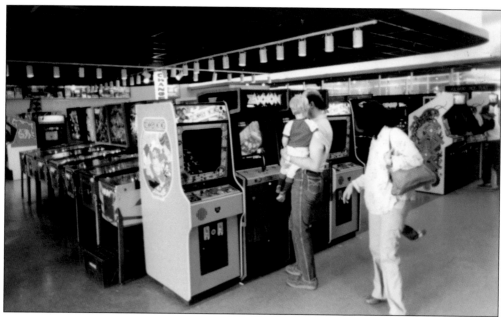

ARCADE, C. 1985. This look inside the Adventureland Arcade shows a few 1980s classics, such as Nintendo's Donkey Kong and Sega's Zaxxon. To the left is a row of pinball games. The arcade still occupies this indoor area of the park today and continues to feature a few classics such as Midway's Ms. Pac-Man and Galaga.

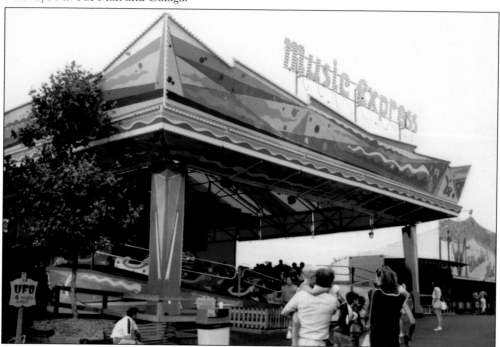

MUSIC EXPRESS AND CHARLIE'S HAT, 1985. The Mack-manufactured Music Express would prove to be an Adventureland favorite for decades. This particular Music Express model featured a loud sound system playing the latest popular music and spun in both forward and backward directions, pushing riders toward the outside wall of their seats with the centrifugal force created by the ride's motion.

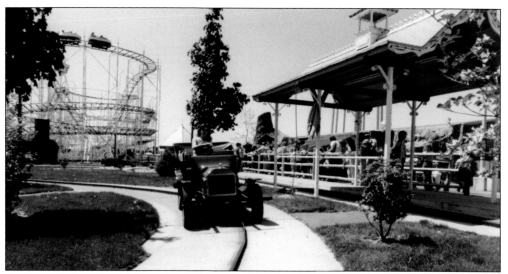

ANTIQUE CARS, GALAXI, AND LOST CONTINENT, 1985. This photograph shows the entrance to the gas-powered Antique Autos, the Galaxi roller coaster, and a rare view of the facade of the Lost Continent in the background on the right. The Lost Continent, a dark ride, was also often referred to as "the Haunted Cave" and "the Haunted House" in park literature through 1985.

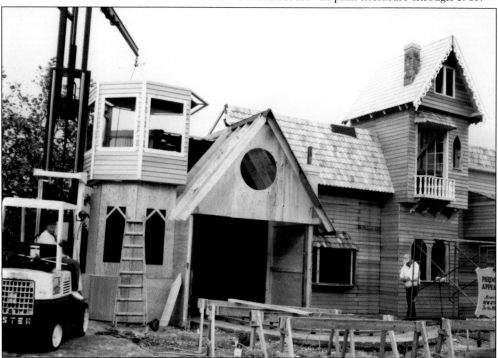

1313 CEMETERY WAY UNDER CONSTRUCTION, WINTER 1985. After the Lost Continent finished its final season at Adventureland, the old volcano and crater-like facade was removed, and the entire warehouse-like show building was gutted. The new attraction, which would debut in the 1986 season, would be the famous 1313 Cemetery Way dark ride that would be an Adventureland fan favorite for years. Under construction here is the new attraction's haunted-house–style facade. (Courtesy of Chip and Kathy Cleary.)

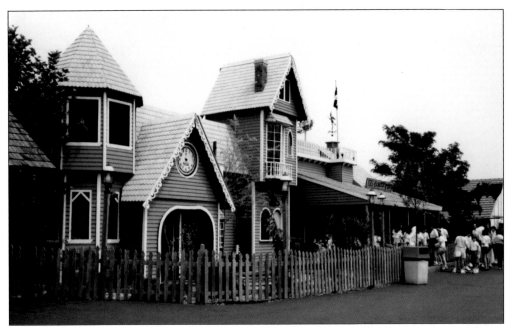

1313 CEMETERY WAY, 1986. The 1313 Cemetery Way attraction would debut to great popularity. Utilizing the same track system and vehicle chassis as the Lost Continent but featuring entirely new show scenes, a digital audio system, and higher walls to contain the audio to each scene, 1313 Cemetery Way was a definitive upgrade over the attraction that it replaced. Other upgrades that came with 1313 Cemetery Way included better lighting, more-elaborate sets, better track sensors to trigger the effects, and air-conditioning.

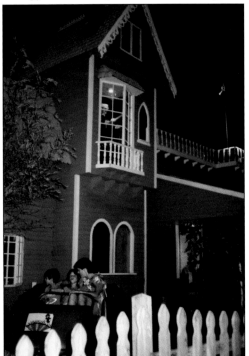

1313 CEMETERY WAY AT NIGHT, 1986. Here, a Haunted Mansion "Doom Buggy"–like ride vehicle featuring the 1980s Adventureland logo makes it way away from the station toward the entry doors of 1313 Cemetery Way. In the right corner is a skull-and-crossbones pirate flag, which often adorned the roof of the building. In the upstairs window is the "Man with the Chainsaw," the one that the infamous animatronic Haunted Tree would be so afraid of in the future. (Courtesy of Chip and Kathy Cleary.)

King Kong inside 1313 Cemetery Way, 1986. This very large, animatronic King Kong would have a long life at Adventureland. Starting inside of 1313 Cemetery Way upon its debut in 1986, King Kong would snarl and roar at guests as their vehicle passed by his New York City subway station scene inside of the attraction. King Kong was one of many completely new show scenes added upon the debut of 1313 Cemetery Way. Other show scenes were manufactured for the attraction by Spaeth Design, a company famous for its work on Macy's holiday windows at Macy's Herald Square on Thirty-fourth Street in Manhattan.

1313 Cemetery Way Exit, 1986. The attraction's haunted-house facade went far down the front of the show building, but this exit area reveals a little bit of the green-walled warehouse that housed the actual ride path and show elements. Some rockwork, visible here, was around the exit doors. Above and to the right is a large bat, looking like a figure out of a classic Bill Tracy dark ride. The bat would be removed in the future, and the exit area would become home to the large, animatronic Haunted Tree and Owl.

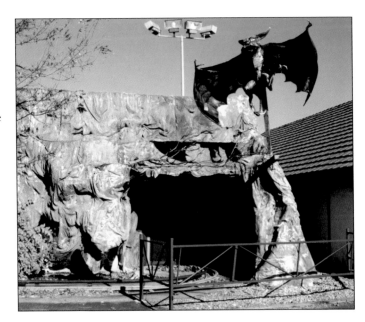

BAVARIAN VILLAGE CONSTRUCTION, WINTER 1983. The 1980s were a time of great thematic growth for the park, changing Adventureland's dynamic from amusement park to a hybrid of amusement and theme park. Part of this transition included the construction of the Bavarian Village in the winter of 1983. Under construction on the right is the Bavarian Village restroom area, and on the left is the park's Photo Emporium, where guests could create their own magazine-cover–style portraits.

COMPLETED BAVARIAN VILLAGE, 1984. The Bavarian Village, once completed, provided a beautiful new themed environment for the park. This small nook would be home to the park's Photo Emporium and Shirt Shoppe and would later become the park's Gift Shop and Sweet Shoppe as well. (Courtesy of Chip and Kathy Cleary.)

ANTIQUE CARS AND BAVARIAN VILLAGE, 1984. The gas-powered vehicles featured here, part of the second iteration of antique-car–style attraction at Adventureland, were manufactured by Arrow Dynamics. While similar antique automobiles also built by Arrow could be found at parks around the country, these particular vehicles began their lives at the 1964–1965 New York World's Fair as part of the Avis Antique Car Ride. They were brought to Adventureland in 1978.

ANTIQUE CARS AND PIRATE'S PLAZA, 1987. Behind this newly rerouted Antique Autos attraction is the new-for-1987 Pirate's Plaza. The very long Antique Autos attraction route was shortened to make room for an entirely new themed area in the back corner of the park.

Pirate's Plaza and Pirate Ship, 1987. HUSS Park Attractions would again produce a fan-favorite ride for the park, the Pirate Ship, for the new Pirate's Plaza in the revitalized back corner of Adventureland. The ship-themed gondola swings back and forth, providing a feeling of weightlessness at the top of the highest swings.

Four

1990s
NIFTY NINETIES

The 1990s in America was a time of carefree fun for many. Pop culture was bursting at the seams and the economy was thriving. During this time under the ownership of Tony Gentile's partnership team, Adventureland saw unprecedented growth, success, and expansion.

The Adventureland brand, under the guiding force and creative vision of Chip Cleary and Udo Storck, would even expand to include the creation of the Splish Splash water park in Riverhead. Another Adventureland property, Bullwinkle's, would open in 1999.

Adventureland during the 1990s was packed from morning until midnight, as the park would truly come alive at night during this decade. While many Adventureland classics would see their last years at the park during this era, many other, newer classics would be added during this era as well.

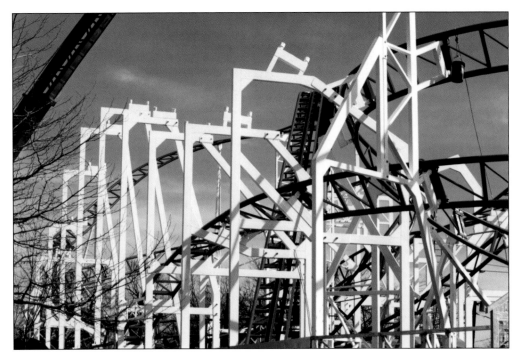

HURRICANE ROLLER COASTER UNDER CONSTRUCTION, WINTER 1990. After the Galaxi roller coaster was sold to a location in Brazil, Adventureland's next move was to purchase an updated roller coaster. Produced by SDC (Spaggiari, Duce, & Casoli), the Hurricane is one of several nearly identical Windstorm/Hurricane models. Its iconic blue-and-white paint scheme has been with the attraction since day one.

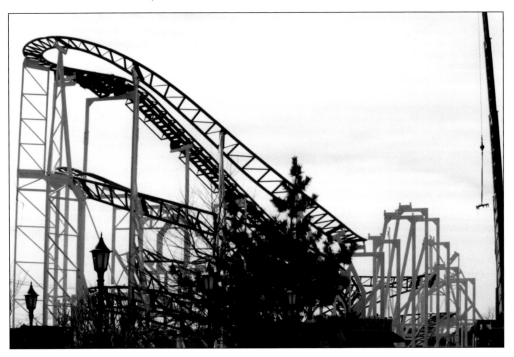

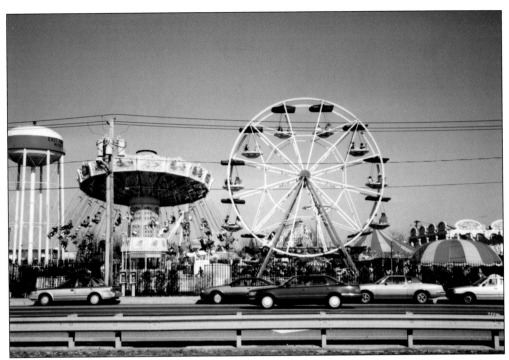

FRONT OF PARK FROM ROUTE 110, 1993. The front of Adventureland on the Route 110 side during the 1993 season featured the Space Age, Merry-Go-Round, Big Wheel, and Wave Swinger. The rides on that side of the park have been a living and breathing advertisement for all drivers passing by since the 1960s.

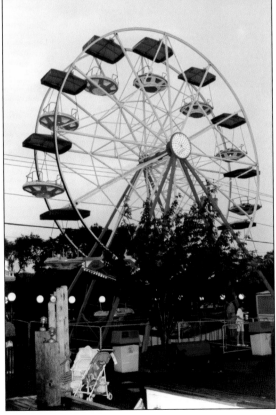

BIG WHEEL FERRIS WHEEL AT NIGHT, 1993. Introduced in Adventureland's 1985 season, the Big Wheel Ferris wheel manufactured by Sartori Rides replaced the park's older Eli Bridge Ferris wheel. The Big Wheel would be a great roadside advertisement for the park and would entertain guests for 10 seasons before being replaced by another Ferris wheel, the Balloon Wheel, in 1995.

47

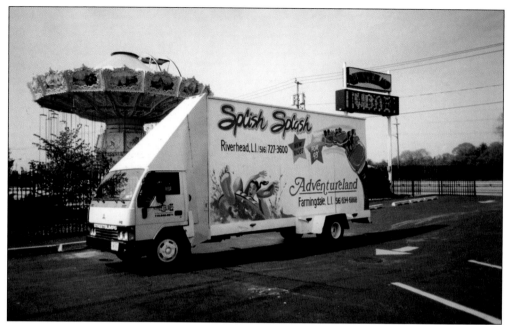

SPLISH SPLASH AND ADVENTURELAND BILLBOARD TRUCK, MAY 1993. Splish Splash water park would open in Riverhead in 1991, a project spearheaded and developed by Chip Cleary, Udo Storck, and Adventureland. At the time, Splish Splash would be under the same ownership as Adventureland and would remain as such through the 1999 season. This billboard truck seen here is advertising both parks.

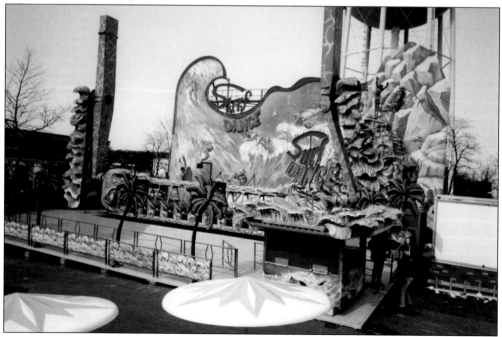

SURF DANCE INSTALLATION, WINTER 1993. The Surf Dance was a Mondial-manufactured Super Nova model attraction. Once open, it would quickly go on to become one of the park's most popular and beloved attractions.

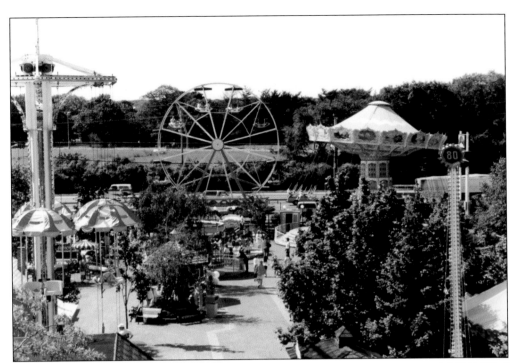

FRONT OF PARK, 1994. This view down the front of the park shows a few changes made from the 1993 season, including the relocating of the Space Age and the Merry-Go-Round. From left to right are the Parachuter, Convoy Race, Kiddie Swings, Flying Clowns, Big Wheel, Wave Swinger, High Striker game, and the Merry-Go-Round. Because many of Adventureland's rides are portable models, they are often shifted or moved between seasons to make room for new additions that may require more space.

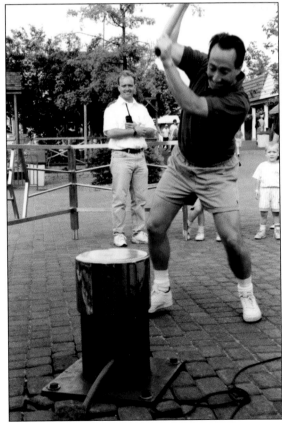

HIGH STRIKER, 1994. Here, a guest tries his luck and swings with all of his might to win a high score and a prize on the High Striker midway game, a modern twist on the hammer-and-bell midway game of yesteryear. The High Striker had a built-in sound track of audio clips that would taunt, mock, or praise a participant's strike. An updated version of the High Striker is located farther up the Adventureland midway today.

MAGIC DRAGONS, 1994. The Magic Dragons was a staple of the park's Kiddie Land section for many years. These happy green dragon/dinosaur gondolas would "hop" up and down as they circled a small volcano in a counterclockwise direction. Children in the front seat could swivel the creature's head back and forth via a lever. The name was changed to Dinosaur Ride in 1996.

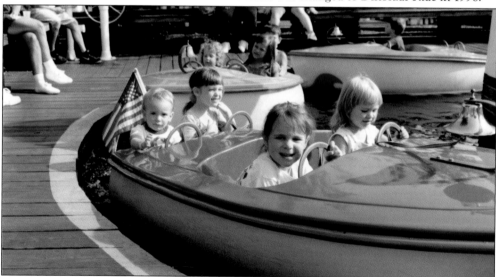

YACHT CLUB, 1994. The longest-lasting original attraction, the Speed Boats, was renamed the Yacht Club when moved to this location alongside the restaurant. Some updates included new paint and flags for the boats, a wooden deck, and a ship's steering wheel; additionally, the lighthouse had a staircase with the Seven Dwarfs from Walt Disney's *Snow White and the Seven Dwarfs* climbing up, and a few were positioned on the catwalk of the lighthouse as well. The ride was renamed Kiddie Boats in 1996.

ADVENTURELAND TRAIN, 1994. This photograph provides a rare view of a black train that was run on the tracks at Adventureland during the 1994 season. Borrowing a page from the naming convention of the trains on Disney's Big Thunder Mountain Railroad attractions, the name of this train is I.M. Reckless.

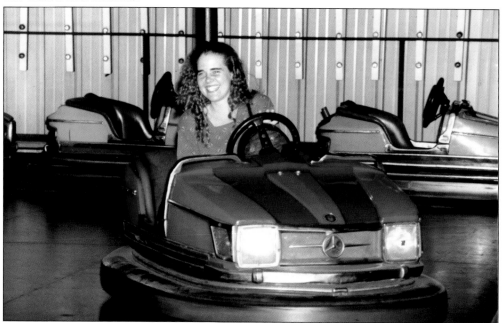

BUMPER CARS, 1994. The Bumper Cars attraction featured here is in the more permanent bumper car ring that was assembled behind Adventureland City Hall. Also pictured is an older set of bumper cars that would be replaced after the 1995 season.

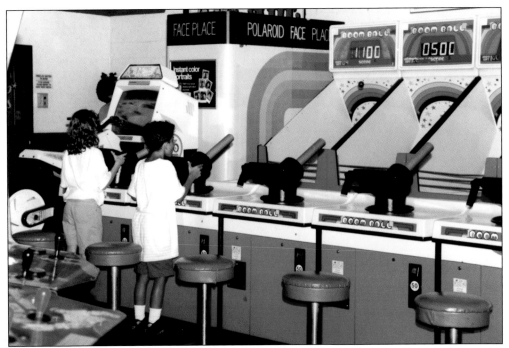

ADVENTURELAND ARCADE, 1994. By 1994, the Adventureland Arcade had evolved and expanded to have much more than classic arcade games and pinball machines. Pictured here is the classic Boom Ball arcade game, where a guest would launch a ball from an air cannon into a Skee-Ball–like set of holes. In the back left is a Polaroid Face Place photo booth.

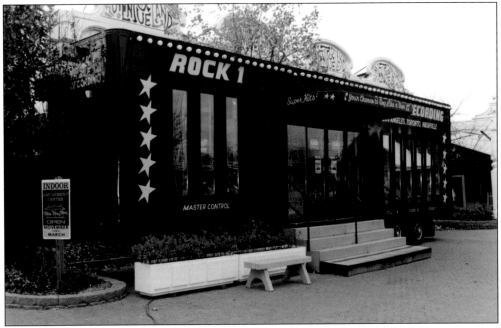

RECORDING STUDIO, 1994. Adventureland's trailer-style recording studio allowed guests to come in and record their own songs. Literature for the recording studio even shows an acoustic drum set present inside of the trailer and very professional recording equipment.

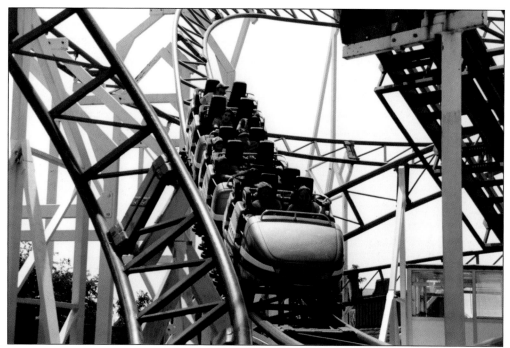

HURRICANE RED TRAIN, 1994. At only four years old, the Hurricane had already thrilled countless Long Islanders. Pictured here is the red train, one of two original roller coaster trains that ran on the Hurricane's track from 1991 until being retired at the end of the 1999 season.

MUSIC EXPRESS, 1994. This particular Music Express thrilled guests for over a decade. It featured a disco ball in the center and was run in both forward and backward directions. Above the exit sign is Albert, a park mascot introduced during the 1980s that was made to look like a safari/jungle adventurer to tie into the name Adventureland.

GIFT GAZEBO, 1994. This image provides a glimpse into the popular culture of 1994. Some highlights include *Mighty Morphin Power Rangers* memorabilia, a Michael Keaton/Tim Burton *Batman* balloon, Bert and Ernie *Sesame Street* balloons, *Looney Tune's* Bugs Bunny and Sylvester the Cat balloons, Baby Bop (from *Barney*) balloons, *Clifford the Big Red Dog* balloons, and very early *Lion King* merchandise, as the movie had only been released in theaters two months prior to the taking of this photograph.

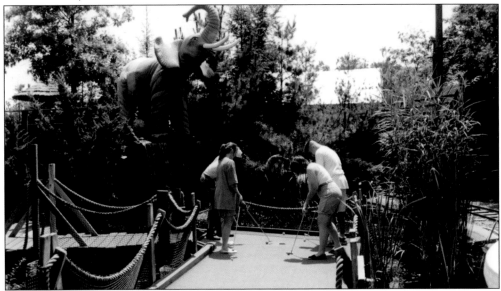

TREASURE ISLAND, 1994. Opened in 1988 as part of the second phase of Pirate's Plaza, Treasure Island would prove to be one of Long Island's favorite locations for miniature golf. The beautiful course was very well themed, and some of the holes were built over a man-made lagoon, with walkways and greens floating in the water. The elephant seen in the background is still visible today from the 110 Express train.

TREASURE ISLAND OVERVIEW, 1994. A view from above shows a great majority of the layout of the Treasure Island miniature golf course. The course was a winner of a *Long Island Magazine* Best of Long Island award for Best Miniature Golf Course. The course would close at the end of the 2000 season to make way for the Adventure Falls log flume.

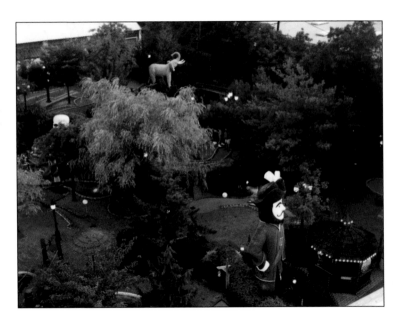

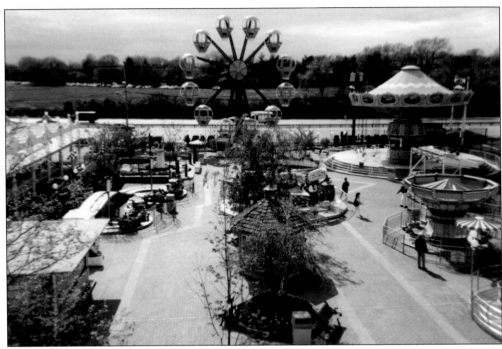

BALLOON WHEEL AND FRONT OF PARK, 1995. Introduced for the 1995 season to replace the Big Wheel, this Zamperla-manufactured Ferris wheel has provided guests with an unforgettable view of Adventureland from above for almost two decades. It became a park icon almost instantly upon installation, and its location on the Route 110 side of the park affords guests driving toward the site a glimpse of the fun-filled and exciting day ahead of them. Pictured, from left to right, are the Convoy Race, Yacht Club, Magic Dragons, Flying Clowns, Balloon Wheel, Wave Swinger, Sooper Jet, and Kiddie Swings.

FLYING CLOWNS IN KIDDIE LAND, 1995. Introduced in 1993, the Flying Clowns was a gentle but fun ride for children. The seats gently rotated in a clockwise motion and lifted at an angle a few feet off of the ground. Each row of the clown gondolas featured black buzzer buttons that would allow riders to produce a game show–style buzzing sound that was audible throughout the Kiddie Land area of the park.

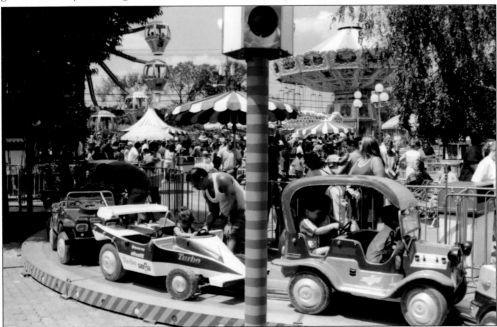

CONVOY RACE, 1995. Manufactured by Sartori Rides, the Convoy Race was a popular Kiddie Land attraction for years before being replaced by an updated kiddie convoy ride named Tour de Paris in 2003. The unique rear car, seen to the left in the picture, was popular amongst children because it featured sit-on dragons instead of being a car or truck vehicle.

PARACHUTE TOWER, 1995. The Adventureland Parachute Tower, introduced to the park in 1990 under the name Parachuter, is billed in the 1990 park literature as "a scaled down version of that Coney Island favorite." Made by the Venture Ride Manufacturing Company, the ride offered young guests a great view of the park.

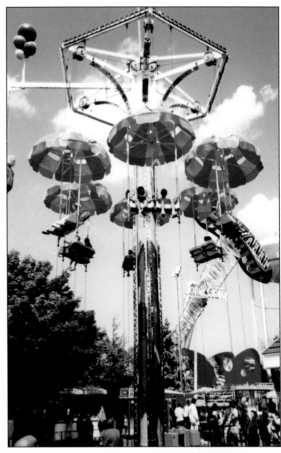

FROG BOG GAME, 1995. The Frog Bog game, right in the middle of the midway, has been popular throughout its entire lifetime at the park. Using a rubber mallet, guests try to win a prize by launching a rubber frog into a floating lily pad rotating in a circle around a central hub inside of a water-filled bog.

SUPER RAIDERS, 1995. Loosely based on the film *Raiders of the Lost Ark*, Super Raiders was a Wisdom Rides Raiders–model attraction. This walk-through attraction featured several obstacles along the way, including sliding floors, a spinning wheel, punching bags, bungee cords, and more. The adventure ended with a long slide to the exit. Super Raiders was replaced with a similar Wisdom Rides model named Pirates Island in 2012.

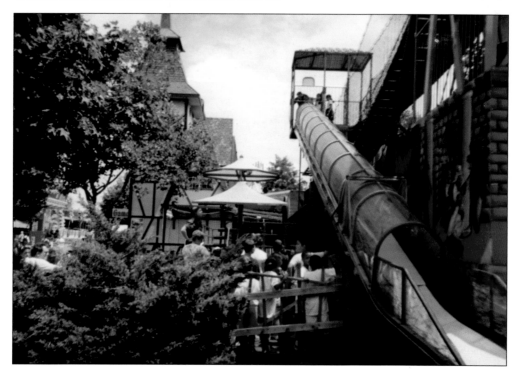

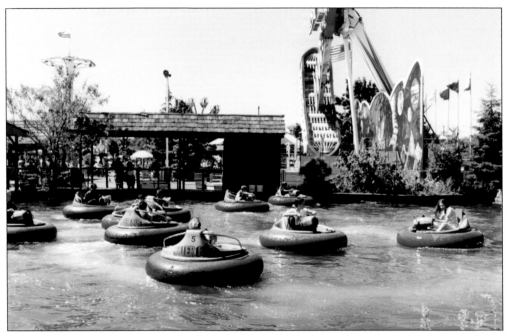

CAP'N WILD WILLY'S BUMPER BOATS AND LOOPING STAR, 1995. Cap'n Wild Willy's Bumper Boats was a popular attraction throughout its lifetime and often commanded a very long line, especially on hot summer days. Behind the Bumper Boats, the Looping Star can be seen mid-cycle.

LIGHTHOUSE AND MUSIC EXPRESS, 1999. The Lighthouse, a small refreshment stand that served Good Humor ice cream bars, slushes, and Coca-Cola products, was located between the Bumper Boats pool and Music Express for many years. It replaced the Scorpion Ice Cream Stand. Today, the Lighthouse can be seen in its retirement location from the Adventure Falls log flume.

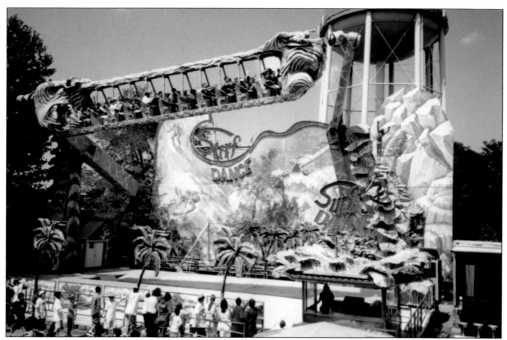

SURF DANCE, 1995. The Surf Dance featured two arms that rotated a 48-seat gondola. The gondola was capable of swinging to angles up to 90 degrees. Depending on the program or manual operation, both arms could swing together in either direction or could swing opposite of each other in different directions, creating distinct sensations for the riders.

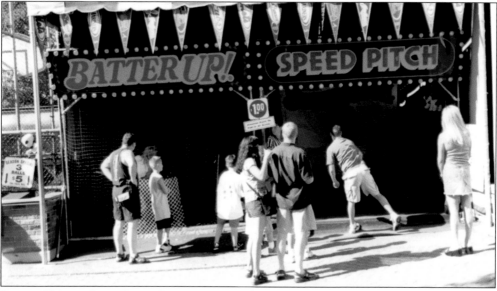

BATTER UP! AND SPEED PITCH GAMES, 1997. Both of these games afforded guests the opportunity to test their athletic abilities. Batter Up! pitched guests several Wiffle balls. Players of the game would try to hit a home run by landing a Wiffle ball on an upper ledge. Speed Pitch required guests to guess the speed of their baseball pitches before the actual speeds were determined by radar gun. Both games were moved to this spot in 1997 from their former location to the left of City Hall.

MUSIC VIDEO RECORDING STUDIO, 1997. Providing both music video and karaoke recording, Adventureland's music video recording studio offered guests the ability to record their own music videos or songs and purchase them on VHS or audio CD, respectively. The studio even had the ability to employ green-screen computer technology.

HAUNTED TREE AND OWL, 1995. Sitting atop the exit of 1313 Cemetery Way, the Haunted Tree and Owl, manufactured by Heimo, quickly became Adventureland icons after their introduction in the late 1980s. The Owl would beckon, "I wouldn't go in there if I were you!" to which the Haunted Tree would reply, "Why not? What's wrong with a little fun in the dark at Adventureland?" Dennis Daniel, an American media personality and character voice actor, provided the voices for both characters.

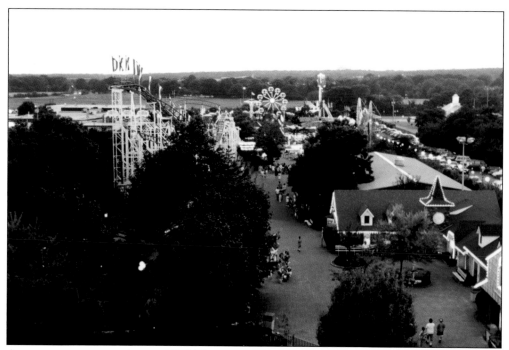

ADVENTURELAND FROM ABOVE, 1995. This nice overview of the park affords a glimpse at, from left to right, the Antique Autos, Hurricane roller coaster, Parachuter, Balloon Wheel, Wave Swinger, Looping Star, Music Express, Surf Dance, 1313 Cemetery Way show building, and Bavarian Village.

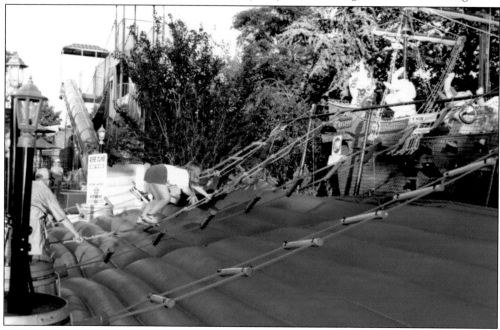

ROPE CLIMB, 1995. In this game of skill, guests climb up toward the pirate ship holding the prizes and honk the horn if they make it to the top of the rope ladder without overturning and falling to the inflatable mattress below. The large pirate ship behind the mattress would see a second life after retirement; it now sits in the old bumper boats pool where the Crocodile Run exists today.

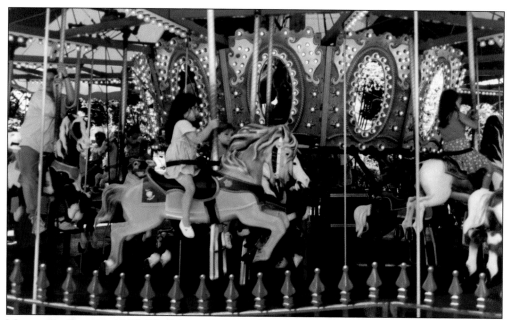

MERRY-GO-ROUND, 1995. The Merry-Go-Round, a Chance-manufactured carousel, would exist at the park in various locations throughout the 1980s and 1990s. In 1999, it would be moved to Bullwinkle's in Medford, a new Adventureland property. The Bertazzon-made Double-Decker Venetian Carousel would replace this Chance carousel for the 1999 season at Adventureland.

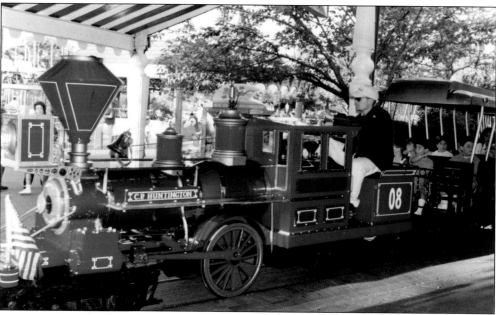

C.P. HUNTINGTON ADVENTURELAND TRAIN, 1995. The C.P. Huntington Adventureland Train carried cars full of guests for several years before being sent to Bullwinkle's (now Boomers!) in Medford. The Chance Rides–manufactured C.P. Huntington Train is a 24-inch–gauge replica of the first train purchased by the Southern Pacific Railroad, a 4-2-4T steam locomotive that was named in honor of Collis P. Huntington, the railway's third president. The Chance C.P. Huntington can be found at various parks across the country.

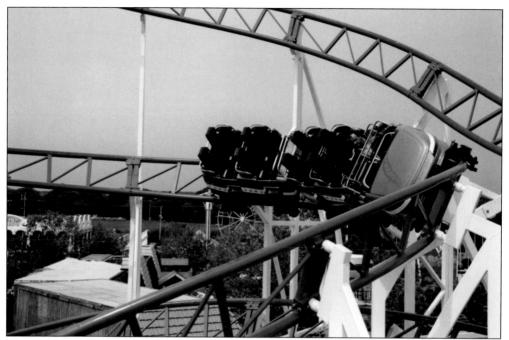

THE HURRICANE MORNING TEST, 1995. Early each morning, before the park opens, a park mechanic will do a ride-through of the Hurricane roller coaster to ensure that it is safe and ready for the day's operation. The mechanic will look, listen, and feel for anything that seems out of the ordinary.

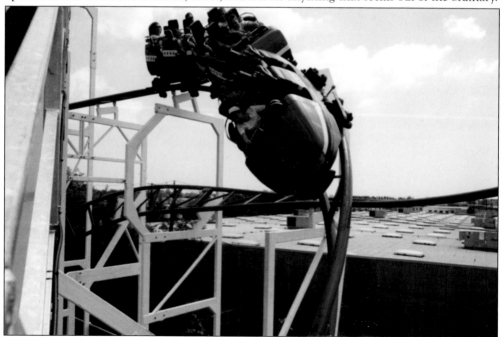

THE HURRICANE'S PURPLE TRAIN, 1995. Here, the Hurricane roller coaster's purple train is about to enter what park literature refers to as an "inverted loop." While riders never actually experience any true inversion on the attraction, this diving drop hits them with some serious forces and an unexpected change in direction.

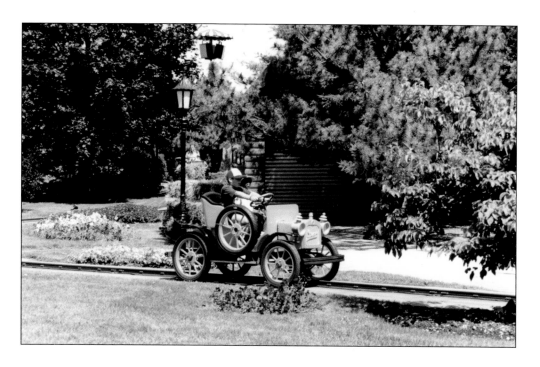

NEW ELECTRIC ANTIQUE CARS, 1995. Adventureland would retire its steerable, gas-powered world's fair Arrow Dynamics cars for these newer, nonsteerable, electric cars in 1993. With the rising cost of gasoline, a changeover to electric cars likely made the best financial sense. These vehicles still carry guests as of 2014.

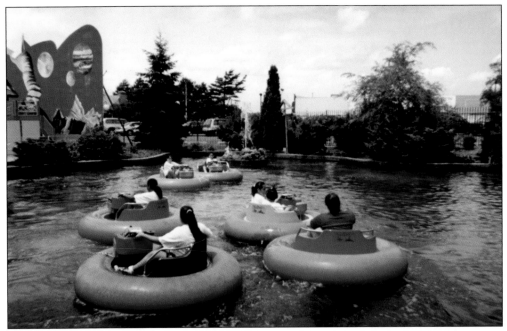

NEW BUMPER BOATS, 1998. Cap'n Wild Willy's retired its original fleet of J&J Amusements Water Bugs and replaced them with a newer set of boats in 1998. Once released from the dock, guests had approximately two full minutes of bump time before being called back in via lifeguard whistle to return to the dock.

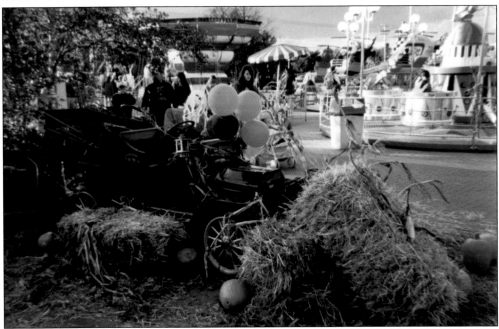

PUMPKIN PARK AND RETIRED ANTIQUE CAR, 1995. Pumpkin Park, an annual Adventureland Halloween tradition, often involves the scattering of bales of hay, pumpkins, and balloons throughout the park. Here, a retired gas-powered world's fair antique car acts as both a prop and a photo opportunity.

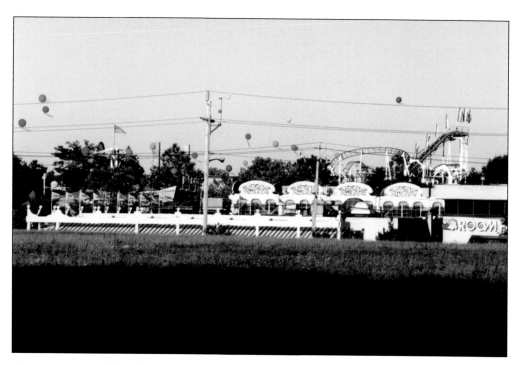

ADVENTURELAND 35TH ANNIVERSARY, 1997. With the 35th-anniversary celebration underway, 35 oversized balloons were spread throughout the park. Above is the view from Route 110, and below is the view from within the park itself. Visible below, from left to right, are the Flying Clowns, Tubs of Fun, Helicopters, Merry-Go-Round, Looping Star, Music Express, Parachuter, Whac-A-Mole game, and Convoy Race.

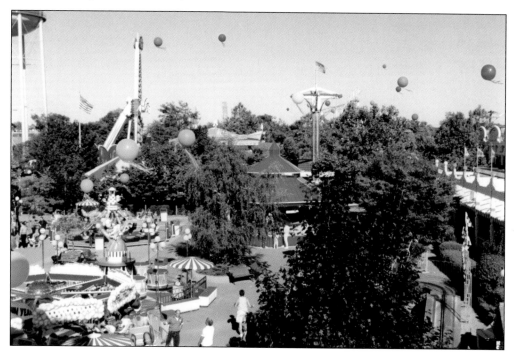

GERMANTOWN UNDER CONSTRUCTION, c. 1997. With the success of the Bavarian Village, another themed project included the construction of new facades and structures to house games and an outdoor location for quick-service food. When completed, the Germantown project added another themed environment to the Adventureland midway.

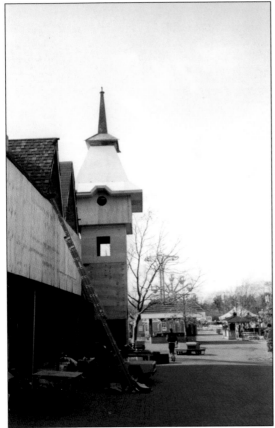

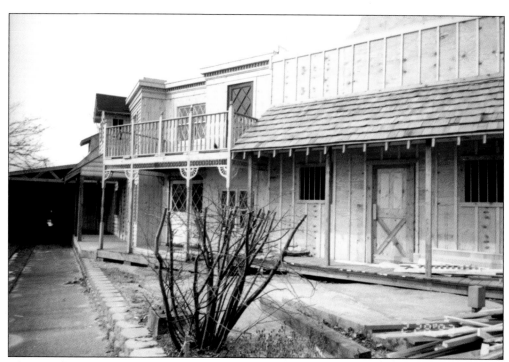

WESTERN TOWN FACADE UNDER CONSTRUCTION, C. 1997. Under construction here during the 1997 season, this facade would help hide the backsides of the games and quick-service food stand on the opposite side, facing the midway. On the far left is the tunnel that the 110 Express used to run through. The tunnel is now the site of the new 110 Express train station that opened in 2012.

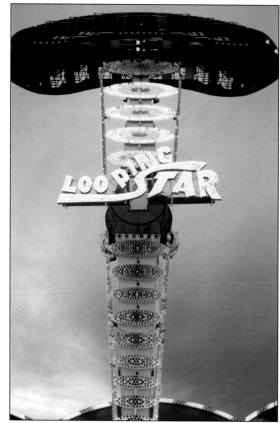

LOOPING STAR MID-CYCLE, 1997. The Looping Star is shown here with its gondola of 40 passengers held in by stomach restraints upside down at a height of 66 feet above the ground. An inverting pendulum ride, this attraction was a fan favorite during its lifetime at the park and was the first upside-down ride that many Long Islanders would experience.

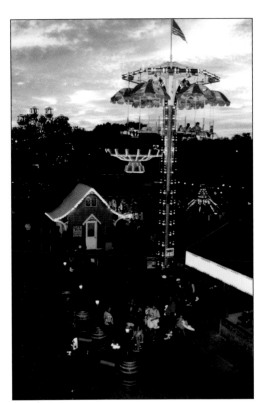

PARACHUTER AT SUNSET, 1997. Parachuter, also known as the Parachute Tower and Parachute, is seen here at sunset. Also in the area are, from left to right, the Rope Climb game, Main Ticket Booth, Whac-A-Mole game, Balloon Wheel, Wave Swinger, Helicopters, and Frog Bog game.

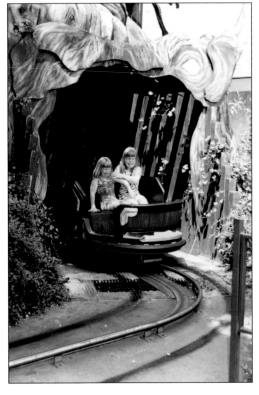

1313 CEMETERY WAY EXIT, 1997. The park's haunted-house–style dark ride, 1313 Cemetery Way, received new vehicles and retired its older green ones. The attraction's spooky interior, animatronics, and props frightened children for decades, as pictured here.

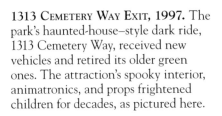

Balloon Wheel Maintenance and New Sweeps, 1998. Before the start of the 1998 season, Balloon Wheel manufacturer Zamperla of Italy sent Adventureland a new set of sweeps for its Balloon Wheel Ferris wheel. The gondolas and the old sweeps had to be removed first before the new sweeps could be installed. The height of the Balloon Wheel is 10 meters, which is about 32.8 feet.

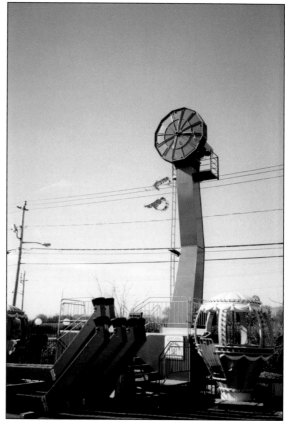

Bubbles in Kiddie Land, 1998. Pictured here is a new bubble machine located above the now retired Good Humor ice cream gazebo. Because of its extreme popularity, a bubble machine of some form has existed at the park ever since.

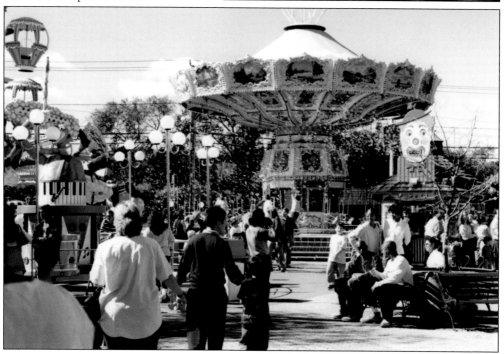

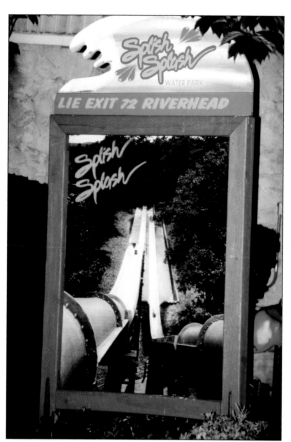

SPLISH SPLASH MAX TRAX WATER SLIDE ADVERTISEMENT, 1999. The 1999 season would be the last in which Splish Splash advertisements remained in the park. Both the 60-acre (at the time) Splish Splash water park and the 9-acre Bullwinkle's family-entertainment center would be purchased from Adventureland ownership by Palace Entertainment at the end of the 1999 season.

1313 CEMETERY WAY FACADE, 1999. Compared to its neat and clean image in the 1980s, the appearance of 1313 Cemetery Way had become more wooded and overgrown in the 1990s. This new look added a more abandoned and spooky look to the attraction's facade. Bach's Toccata and Fugue in D minor would play on an organ as guests entered through the green doors leading into the attraction.

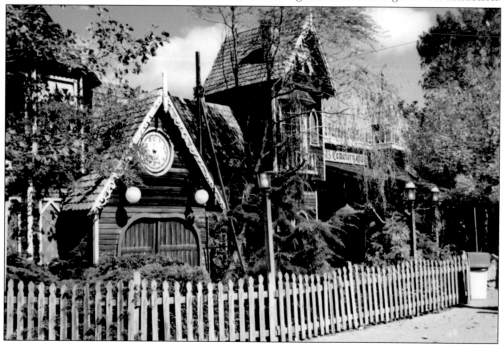

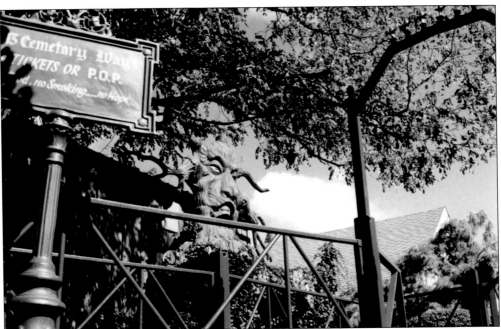

1313 CEMETERY WAY SIGNAGE AND ICONS, 1998. Referred to in some fan communities as 1313 "Cemetary" Way because of how it was misspelled on the attraction's signage, 1313 Cemetery Way existed in various forms at Adventureland for over two decades. The Haunted Tree and Owl animatronics would frighten many small children with their lines such as, "Chainsaws? I don't like chainsaws! I once had a close shave with one! And by the way, if I get my limbs on you!" The Haunted Tree and Owl were unique to Adventureland and are truly icons of the park.

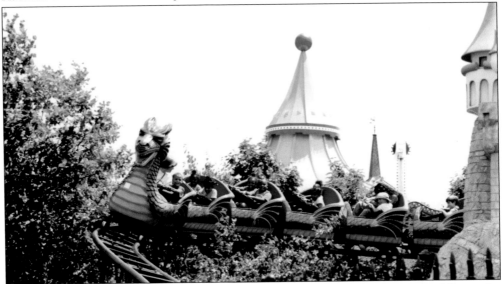

DRAGON WAGON, 1999. First introduced in 1996 as a replacement for the powered Sooper Jet roller coaster, this Wisdom Rides–manufactured, gravity-powered kiddie roller coaster featured a spiral tire-driven lift hill and two helices. The Dragon Wagon would run two complete circuits on each cycle out of the station. It was relocated to Blackbeard's Cave in Bayville, New Jersey, where it is still in operation as of 2014.

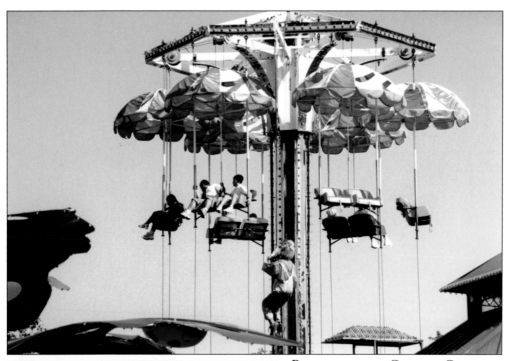

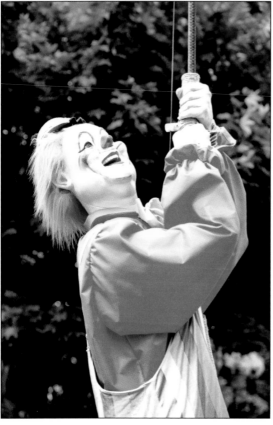

PARACHUTER AND CLIMBING CLOWN, 1999. Pictured here is the Parachuter with an attached clown robotic that would "magically" climb up and down a rope alongside the ride itself. The clown climbed his rope endlessly throughout the day and was a magic touch added to the park during the 1990s.

KING KONG ATOP THE ROCK WALL OF
ADVENTURE, 1999. The 1999 season
featured the addition of a brand-new
climbing wall up-charge attraction for guests.
Atop the Rock Wall of Adventure was
placed the giant animatronic King Kong
that had just been removed from its former
home at 1313 Cemetery Way. The Rock
Wall of Adventure offered three courses for
different skill levels. If one made it to the top
and pressed a button located on the highest
neon-colored rock, King Kong's eyes would
light up, and he would move and roar.

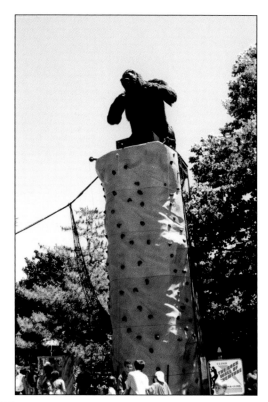

A LOOK DOWN THE MIDWAY, 1999. This
view down the Adventureland midway
provides a view of a child rappelling
down the Rock Wall of Adventure, the
skeleton bike and passenger that used to
go across the midway near 1313 Cemetery
Way, the Music Video Recording Studio,
Surf Dance, and Music Express.

GIFT GAZEBO, 1999. The Gift Gazebo offers a glimpse into the popular culture of 1999. Bert and Ernie, two of the most popular *Sesame Street* Muppets, have now been joined by Cookie Monster and Elmo in the balloon offerings. Other items represented here are inflatable aliens, smiley-face creatures, the "¡Yo quiero Taco Bell!" dog, Scooby Doo, Mickey and Minnie Mouse, Pooh and Tigger, Chuckie and Angelica from *Rugrats*, Pikachu from *Pokémon*, and Barney and Baby Bop balloons. Also popular at this time were "walkable" souvenirs, which included walkable dinosaurs, invisible dogs, aliens, dolphins, and foam dogs.

TREASURE ISLAND MINIATURE GOLF, 1999. Featured here in one of its last seasons before being replaced by Adventure Falls is the Treasure Island miniature golf course. While some of the holes on this particular course were extremely elaborate, others hearkened back to the classic miniature golf course of days gone by. Here, a little girl tries her luck at getting her golf ball through a classic loop obstacle. This exact loop, a relic of the retired attraction, can still be seen today from the 110 Express Adventureland Train.

Five

2000s
The New Millennium

As at many amusement parks across the country, the new millennium meant a shift away from large thrills to better attract a more family-oriented audience. Many new attractions would be added during this era that would focus on children and family, and some of the additions made during this period have proven to be among the park's most popular attractions.

ANTIQUE CARS AND LADY BUG ROLLER COASTER, 2000. New for 2000 was a Zierer Tivoli medium-model roller coaster that had begun its life at Navel Park in Japan. Originally intended to be named *Paul Bunyan Express* and to feature mine-train–themed trains, the coaster instead featured ladybird (another term for *ladybug*) trains and a red track. The Antique Autos path had to once again be rerouted and shortened to accommodate this new attraction.

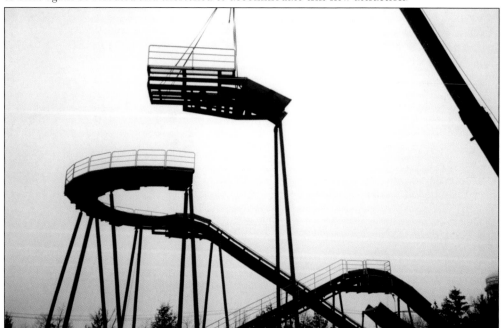

ADVENTURE FALLS LOG FLUME CONSTRUCTION, WINTER 2000. Manufactured by ABC Rides of Switzerland, Adventure Falls is photographed here under construction in the winter of 2000. A crane is busy lifting into place the first segment of flume trough for the attraction's large final drop. Adventure Falls was built directly over the park's retired Treasure Island miniature golf course in response to Long Islanders' demands for more water attractions.

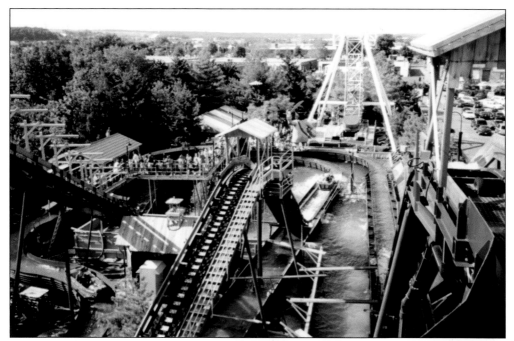

ADVENTURE FALLS, 2001. Adventure Falls proved to be Adventureland's most popular attraction in 2001 after its introduction at the beginning of the season, evidenced by the photograph above showing a long queue of guests waiting to ride. Despite being a portable model of log flume, Adventure Falls offers two drops of 23.6 feet and 38.4 feet, reaches speeds of up to 37 miles per hour, and features a ride length of approximately three minutes and twenty seconds. The picture at right shows now retired park mascot Albert cooling off on the ride itself.

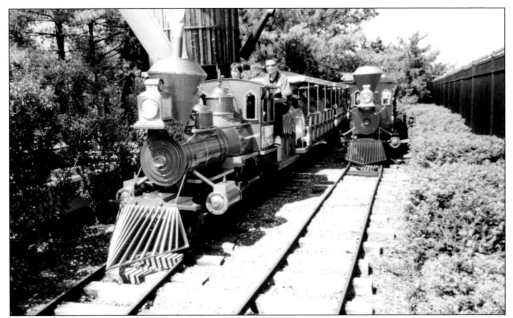

IRON HORSE TRAINS, 2001. The Allan Herschell Company of Buffalo, New York, made over 100 installations of these Iron Horse miniature diesel-engine trains. Here, the park's blue Iron Horse train passes by the park's red Iron Horse train. The red Iron Horse spent some of its time at Bullwinkle's as the Toonville Express before coming back to Adventureland. The Allan Herschell Company would later merge with rival manufacturer Chance Rides in 1970.

PARACHUTER DECONSTRUCTION, WINTER 2001. The offseason leading into 2002 was a busy one. Like Looping Star, Parachuter was also retired at the end of the 2001 season. Unlike Looping Star, however, Parachuter was not a portable attraction, and the tower had to be carefully deconstructed and removed.

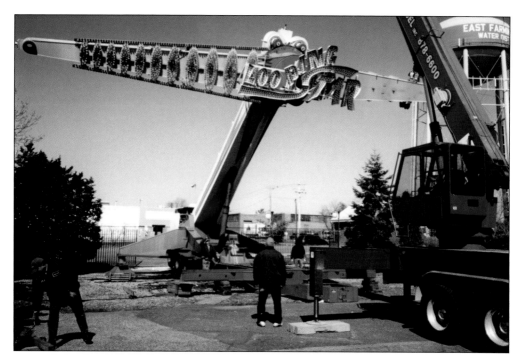

LOOPING STAR GOOD-BYE, WINTER 2001. After the 2001 season came to a close, the Looping Star was disassembled and trailer mounted. Like many Adventureland rides, Looping Star was a portable trailer-mounted ride. After almost 20 years of service, it had been retired to make way for the park's next major thrill ride, Top Scan. Adventureland's Looping Star can still be found today traveling a major fair circuit in Spain.

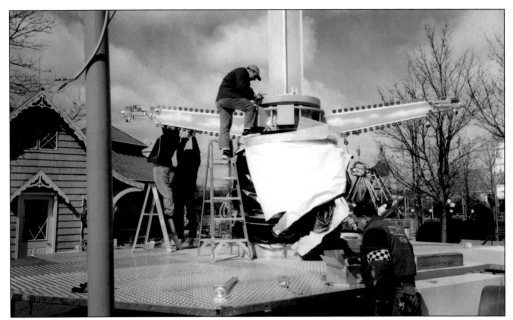

BALLOON TOWER INSTALLATION, WINTER 2001. The SBF-manufactured Balloon Tower is pictured here being installed for the 2002 season. The Balloon Tower was the replacement ride for Parachuter, offering guests a similar aerial view of the park. Each hot-air-balloon gondola can be rotated like a tea cup ride via a central spinner.

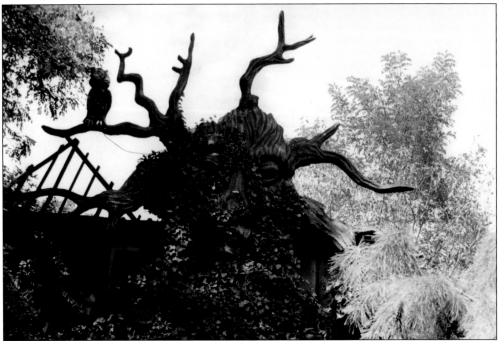

HAUNTED TREE AND OWL VINE GROWTH, 2002. Sadly, the extremely popular and iconic Haunted Tree and Owl became the victims of an uncontrollable vine growth that would quickly cover them. The growth had become so uncontrollable that vines got into the inner workings of the animatronics and eventually prevented the animatronic tree from working at all.

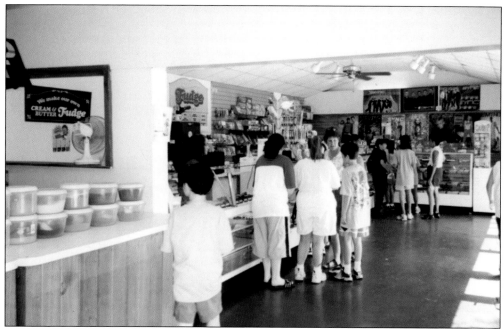

ADVENTURELAND FUDGE SHOPPE, GIFT SHOPPE, AND SAND ART, 2002. Pictured here are the old Adventureland Fudge Shoppe and the exit area of the Gift Shoppe. On the left-hand side are containers of colored sand that would be used for sand art (guests could purchase bottles to fill with the colored sand of their choice).

KIDDIE LAND AT SUNSET, 2002. Featured here are, from left to right, the Sweet Shoppe, Balloon Wheel, Moser-manufactured Hip Hop (introduced in 2001), Sartori-manufactured Tubs of Fun, Wave Swinger, and Zamperla-manufactured Helicopters. The lighting packages on all of the rides provide the park with a very different and exciting look at night.

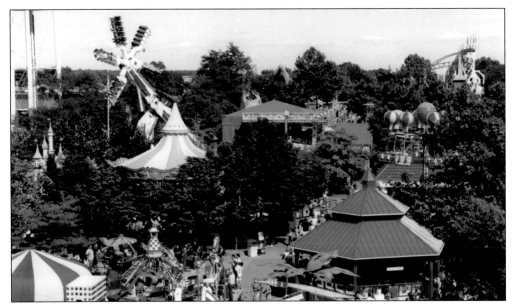

MIDWAY FROM ABOVE, 2003. For the 40th anniversary of Adventureland in 2002, three brand-new attractions were added to the park. A Mondial-manufactured Top Scan replaced the park's Looping Star attraction, a new Mack-manufactured Musik Express replaced the park's older Mack-manufactured Music Express, and an SBF-manufactured Balloon Tower replaced the park's Venture Rides–manufactured Parachute Tower. Visible in this picture are, from left to right, the Helicopters, Venetian Double-Decker Carousel, Top Scan, Musik Express, Surf Dance, Hurricane, Balloon Tower, and Whac-A-Mole game.

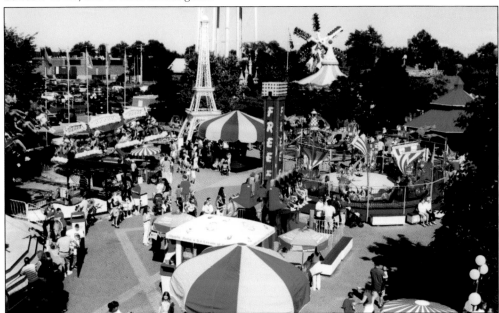

KIDDIE LAND FROM ABOVE, 2003. The 2003 season featured the installation of the Zierer-manufactured Viking Voyage, which replaced the Kiddie Boats, the park's last original opening-day attraction from 1962. Here, from left to right, are the Wave Swinger, Crazy Caterpillar, Flying Clowns, Tour de Paris, Top Scan, Helicopters, Musik Express, Hip Hop, Viking Voyage, and Balloon Tower.

Six

2010s AND BEYOND
THE ADVENTURE CONTINUES

With the second decade of the new millennium already underway, many new and exciting things are sure to be in store for Adventureland Long Island. The park will continue to grow, despite being landlocked, by constantly adding new attractions and reinventing itself to best meet guests' needs along the way.

The park celebrated its 50th anniversary in 2012, marking half a century of providing family fun for Long Islanders, and it looks forward to creating many more memories and celebrating many more anniversaries in the future.

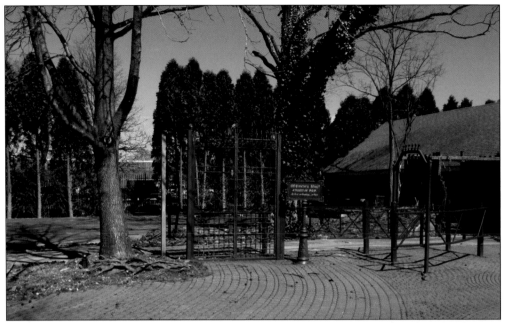

1313 Cemetery Way Removal, Winter 2009. In winter 2009, the entire 1313 Cemetery Way attraction and show building was removed and demolished. The "1313 Cemetary Way" iron signage has not been removed, however, and still exists at the park as of 2014.

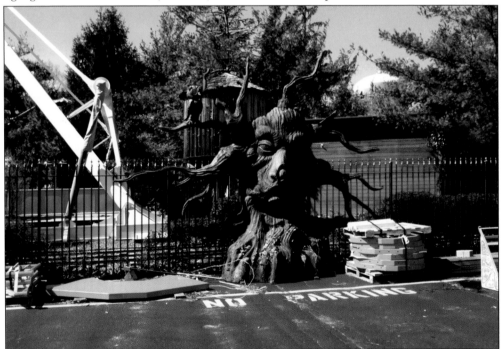

Haunted Tree and Owl in Parking Lot, Winter 2009. With the removal of 1313 Cemetery Way, the Haunted Tree and Owl animatronics that rested on top of the attraction were temporarily laid to rest as a photograph spot at the back of the park. The Haunted Tree finally had all of the vines that had grown around it removed, but at this point, it was still completely nonfunctional.

GHOST HOUSE ARRIVAL, WINTER 2009. The park purchased a portable haunted house attraction named Geister-Rikscha to replace 1313 Cemetery Way. *Geister-Rikscha* translates from German to English as "Ghost Rickshaws," and the ride, manufactured in the 1970s by Mack Rides, was a popular attraction on the German traveling circuit before being acquired by Adventureland.

GHOST HOUSE ASSEMBLY, WINTER 2009. This photograph offers a view of the assembly process for the track for the Ghost House at Adventureland. The floor arrived in many sections, as did the track, and both had to be assembled on-site. The blue container, a trailer, contains some of the ride vehicles and pieces of the facade, showing how an entire large attraction can be made portable.

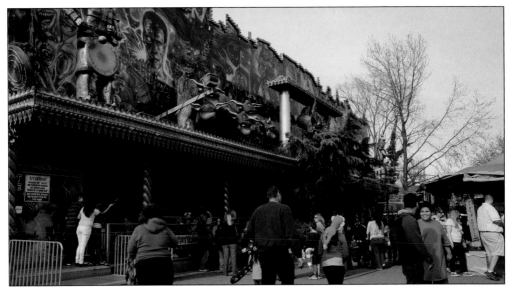

GHOST HOUSE FACADE, 2013. The Ghost House dark ride, introduced in 2010, saw major improvements to its interior show scenes and exterior in 2013 in anticipation of Adventureland's "Nightmare On The Midway" scare event. In the background, the park's now retired Sky Trail attraction is visible as a standing but not operating attraction. To the right is the popular Ring-A-Bottle midway game. (Courtesy of the author's collection.)

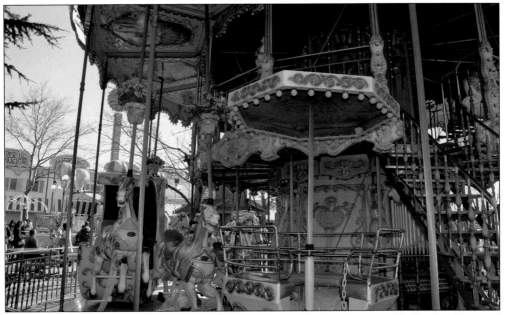

VENETIAN DOUBLE-DECKER CAROUSEL, 2014. The beautiful Venetian Double-Decker Carousel was introduced to the park in 1999 and was manufactured by Bertazzon, an amusement ride manufacturer based in Italy. In 1999, this particular kind of carousel was, as according to park literature, "truly a one of a kind in the NY Metro area—A double decker carousel with elaborate chariots, spinning tubs, hand crafted horses and lights, lights, and more sparkling lights!" In the background are the iconic stained-glass Adventureland signs atop the restaurant and arcade. (Courtesy of the author's collection.)

Frisbee, 2013. The HUSS Park Attractions Frisbee was introduced to Adventureland in 2006 after the removal of the Surf Dance attraction. Similar to Adventureland favorite the Pirate Ship and manufactured by the same company as well, the Frisbee takes the concept of the Pirate Ship to the next level by adding a gondola that can be powered to spin in either direction while the pendulum swings back and forth. (Courtesy of the author's collection.)

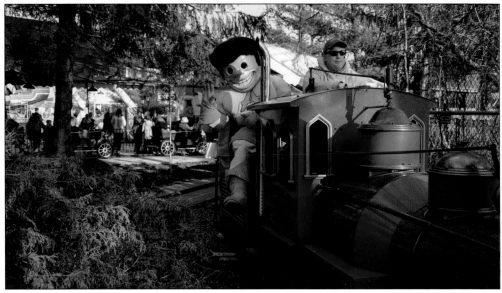

Alfie Adventureland and the 110 Express, 2013. Introduced for the 50th anniversary, Alfie Adventureland became the park's new superhero mascot starting in 2012. His father, Albert Adventureland, retired at the end of the 2011 season, which made way for Alfie to take over the mascot duties. In this picture, Alfie is helping a longtime train conductor engineer the 110 Express around its tracks. (Courtesy of the author's collection.)

Introduced in 2012 as
part of Adventureland's
50th anniversary was a
brand-new back ticket
booth for the park. The
new building features
a beautiful new retro
LED Adventureland
sign that offers many
different color patterns
and sequences.
(Courtesy of the
author's collection.)

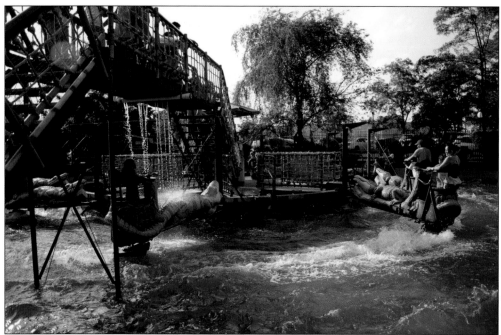

CROCODILE RUN, 2013. The Crocodile Run, a Zierer Jet Skis–model ride, replaced Cap'n Wild
Willy's Bumper Boats in 2003. One or two guests board each individual crocodile. Once in
motion, the crocodiles spin around a central hub, and guests can control their crocodile via a
steering wheel and can swing their gondola left toward the hub or out toward the edge of the
pool. (Courtesy of the author's collection.)

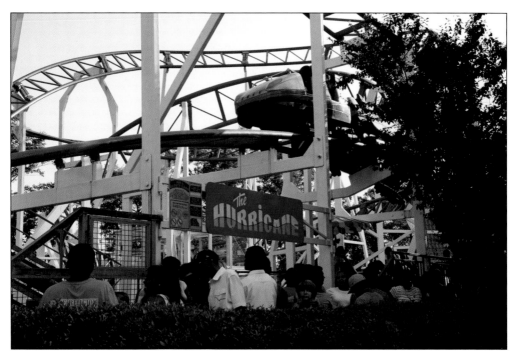

HURRICANE ROLLER COASTER, 2013. The Hurricane celebrated is 23rd anniversary at the park in 2013. The ride received a new set of trains in 2000; both are silver with a colored stripe of either yellow or red to help identify them. The Hurricane has a height of 59 feet and a top speed of approximately 35 miles per hour, and it is a milestone coaster in that it is the first big roller coaster that many Long Islanders ride. (Both, courtesy of the author's collection.)

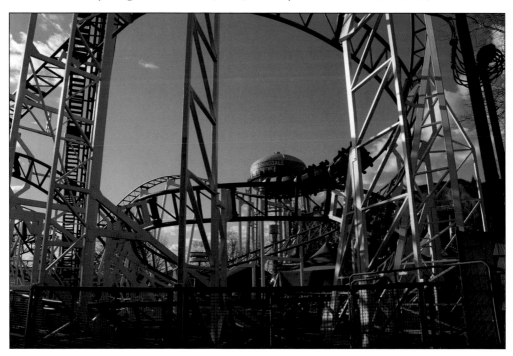

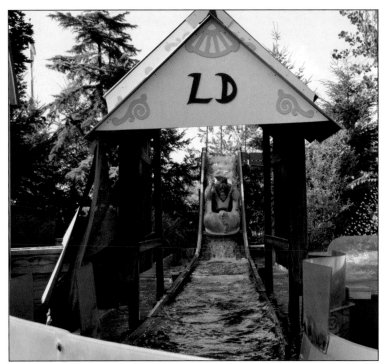

LITTLE DIPPER LOG FLUME, 2013. The Little Dipper was introduced in 2006 and was manufactured by ABC Rides of Switzerland. This attraction offers children too small to ride Adventure Falls the opportunity to experience similar thrills via a smaller flume ride with smaller boats. The Little Dipper occupies the same spot formerly occupied by the Looping Star. (Courtesy of the author's collection.)

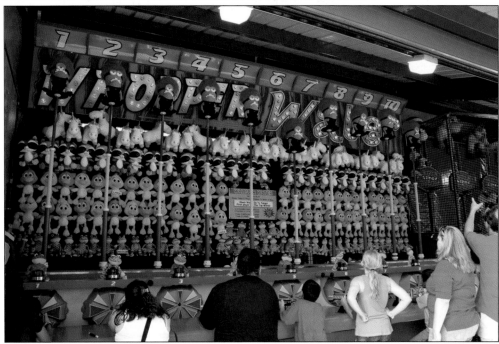

WHOPPER WATER, 2013. New for 2013, the Whopper Water game replaced the park's old Rising Waters game. Manufactured by Bob's Space Racers of Florida, it is a spectacular water gun game that requires players to shoot water at a target. Once the target is triggered, the player's particular podium will rise with a plush toy atop. The winner is the person with the first plush toy to make it to the top. (Courtesy of the author's collection.)

ADVENTURELAND STAGE, 2013. New for 2013, the Adventureland Stage replaced the former temporary stage that had been made using old steel platform pieces leftover from the Surf Dance. This new Adventureland Stage was home to Adventureland's Hot Talent Show and *The Magic and Comedy of Jim McLenahan* in 2013. Stage lighting would later be added. (Courtesy of the author's collection.)

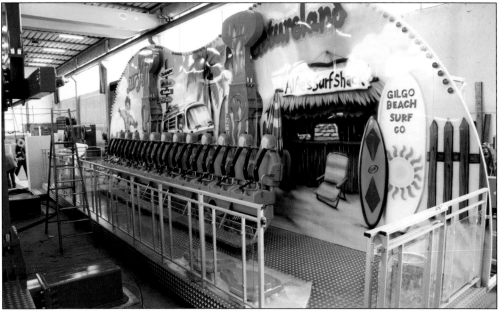

ALFIE'S SURF'S UP AT THE SBF-VISA RIDES FACTORY, 2013. A new surf-inspired attraction—Surf's Up—was added to the park in 2013. This photograph offers a rare look at a newly built ride assembled for tests at a manufacturing facility before being sent to its new owner. Surf's Up, manufactured by SBF-Visa Rides of Italy, features a custom backdrop that makes references to Adventureland history and Long Island culture.

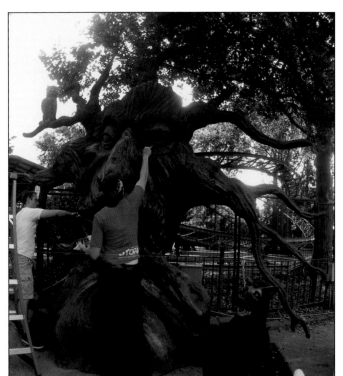

HAUNTED TREE RESTORATION, 2013. After over a decade of being nonfunctional, the park's iconic Haunted Tree saw a full refurbishment spearheaded by Christopher Mercaldo and animatronics specialist Stephen Claiborne. Dried vines still blocking the moving parts had to be removed, holes had to be patched and covered with latex, and the entire tree then received a fresh paint job from top to bottom. Additional work included updating the fittings for the pneumatics that drive the motions and expressions of the limbs, eyes, nose, and mouth of the animatronic. (Courtesy of the author's collection.)

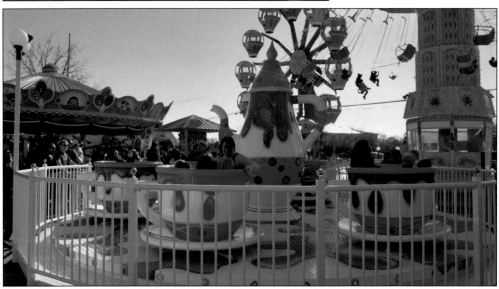

TEA CUPS AND FRONT OF PARK, 2014. The end of the 2013 season saw the retirement of the park's SBF-Visa Rides–manufactured Flying Puppies attraction, with its 2014 replacement being a true amusement park classic, a spinning Tea Cups ride also manufactured by SBF-Visa Rides of Italy. The next generation of Adventureland family members is excited to continue on the amazing legacy of family fun that has been set before it and seeks to bring even bigger smiles and even more fun to the thousands of guests from Long Island, Queens, and Brooklyn that visit the park each year. The slogan "It's all about the kids!" rings true for both the real kids and the kids at heart. The best is yet to come for Adventureland Long Island! (Courtesy of the author's collection.)

ADVENTURELAND LOGOS.
No matter where on
Long Island an individual
is from, he or she is
bound to recognize at
least one of these logos
and associate it with the
park and with fun. Over
the past two decades,
the park has adopted
a typeface logo that
is themed differently
each year. Notable logos
here include the Albert
Adventureland logo
from the 1980s and the
50th-anniversary logo
from 2012. (Courtesy of
the author's collection.)

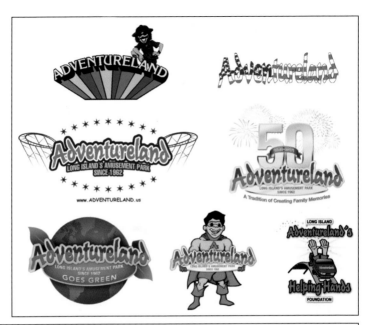

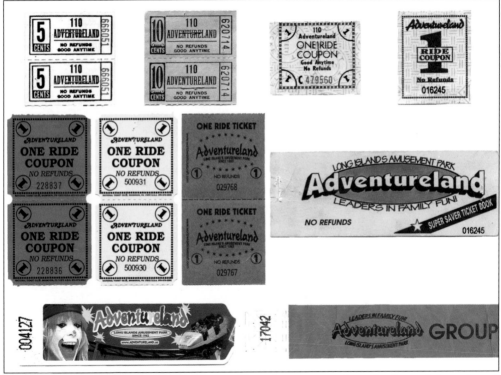

TICKETS, PLEASE. A history of park tickets and bracelets is present here. At the top left are 5¢ and
10¢ tickets dating back to the 1960s era of the park, when it was still called 110 Adventureland;
beneath them are larger, square ride tickets from the 1980s and 1990s. POP (Pay One Price)
bracelets and group/party bands are also Adventureland signatures. Some children keep their
colored POP bracelets on long after their Adventureland visit as a souvenir of their trip to the
park. (Courtesy of Adventureland and the author.)

DISCOVER THOUSANDS OF LOCAL HISTORY BOOKS
FEATURING MILLIONS OF VINTAGE IMAGES

Arcadia Publishing, the leading local history publisher in the United States, is committed to making history accessible and meaningful through publishing books that celebrate and preserve the heritage of America's people and places.

Find more books like this at
www.arcadiapublishing.com

Search for your hometown history, your old stomping grounds, and even your favorite sports team.

Consistent with our mission to preserve history on a local level, this book was printed in South Carolina on American-made paper and manufactured entirely in the United States. Products carrying the accredited Forest Stewardship Council (FSC) label are printed on 100 percent FSC-certified paper.

MADE IN THE